David Cordingly

Painters of the Sea

A survey of
Dutch and English marine paintings
from British collections

Lund Humphries, London
in association with
The Royal Pavilion, Art Gallery and Museums, Brighton

First edition 1979
Published by
Lund Humphries Publishers Ltd
26 Litchfield Street London WC2

SBN 85331 425 X

Made and printed in Great Britain
Typeset by Keyspools Ltd, Golborne,
Lancashire
Printed and bound by Lund Humphries,
Bradford, Yorkshire

This is the catalogue of the exhibition 'Painters
of the Sea' held at the Art Gallery and Museum,
Brighton from 5 May to 29 July 1979

Cover illustration
Detail of colour plate 1 (cat.9)

CONTENTS

page 7 **Foreword**

9 **List of Artists**

11 **Introduction**

13 The historical background

17 Colour plates I–VIII

25 Marine art in Britain

29 **The Dutch Masters**

Cat. 1–14

43 **The British School**

Cat. 15–95

122 **Bibliography**

Photograph acknowledgments

Her Majesty The Queen: 15, 22, 26
Michael Appleby: colour plate VII; 90
John Barrow: colour plate III; 2, 3, 11, 24, 25,
 31, 32, 39, 43, 51, 53, 55, 75, 77, 78, 89, 92
Peter Brett: Fig.2
British Museum: Fig.6
Mr and Mrs F. B. Cockett: 4, 12, 13, 36, 40, 54,
 79
John Edwards: colour plate VI
Ferens Art Gallery, Kingston-upon-Hull: 21,
 74, 76
Guildhall Art Gallery: colour plate VI; 69, 70,
 86
Lord Howick: 56
Laing Art Gallery, Newcastle-upon-Tyne:
 colour plate VIII; 42, 46, 65, 80, 93
Manchester City Art Gallery: 64, 66
Medici Society, London: colour plate VII
National Gallery, London: colour plate I; Fig.3;
 5, 7, 8, 9
National Maritime Museum: colour plates II, IV,
 V; Fig.1; 1, 16, 20, 23, 24, 25, 27, 28, 31, 32,
 33, 37, 39, 43, 45, 48, 55, 57, 75, 77, 78
Norwich Castle Museum: 41, 59, 83, 84, 85
N. R. Omell: colour plate III; 29, 35, 82, 88, 94,
 95
Royal Holloway College, Egham: 87
Royal Pavilion, Art Gallery and Museums,
 Brighton: 2, 3, 11, 51, 53, 89, 92
Tate Gallery: 34, 44, 49, 71
Victoria and Albert Museum: 52, 58, 63, 68, 73
Victoria Art Gallery, Bath: Fig.5
Wallace Collection: Fig.4
Whitworth Art Gallery, Manchester: 50, 62, 81,
 91
Yale Center for British Art: Fig.7

FOREWORD

It is appropriate that Brighton should provide a location for this exhibition of seascapes. The town has attracted more than its share of artists over the past two hundred years. Rowlandson paid a visit in 1789 and depicted the beach and the races; De Loutherbourg included *Brighthelmston, fishermen returning* in his series of views of the English seaside; Constable's oil sketches of Brighton beach are acknowledged to be amongst his most original works, and Turner's golden vision of the Chain Pier is one of his most familiar paintings. Numerous lesser-known painters and watercolour artists came in search of picturesque subjects; several took up residence in the town.

This exhibition, however, is not devoted to local views, but is a comprehensive survey of marine art in Britain. Inevitably there are omissions, but in spite of difficulties the response from lenders, beginning with Her Majesty The Queen, has been most generous, and we believe that the quality and variety of marine paintings shown in the exhibition will provoke admiration from those hitherto unfamiliar with the subject.

Financial support for the exhibition has come from the Arts Council of Great Britain, the Brighton Festival Society, and Brighton Corporation, to all of whom we are grateful. The theme of the exhibition was suggested by Mr David Cordingly, a most valued former colleague; he has selected the pictures and written the catalogue. Much of the early work in organising the exhibition was carried out by Dr Duncan Simpson; on his departure to take up another post the work was ably taken over by Alison Packer and Stella Beddoe. Other members of the staff of the Royal Pavilion, Art Gallery and Museums to whom particular thanks are due are Messrs. Michael Jones, St John Child, Stuart Powell and George Novelle.

The exhibition would have been impossible without the encouragement and assistance of the staff of the National Maritime Museum at Greenwich. We are aware that their generous loan of twenty-four paintings and watercolours entailed them in a considerable amount of administrative and conservation work, and we would especially like to thank Mr Westby Percival-Prescott, Miss Gillian Lewis, Mr Harley Preston, Mr Roger Quarm and Mr David Taylor for their efforts. The staff of many other museums and art galleries have been most helpful and particular thanks are due to Mr Martin Butlin of the Tate Gallery, Mr Michael Levey and Mr Christopher Brown of the National Gallery, Dr Michael Kauffmann of the Victoria and Albert Museum, Mr Francis Cheetham and Dr Miklos Rajnai of the Norfolk Museums Service, Mrs Lesley Dunn of the Ferens Art Gallery, Miss Gill Hedley of the Laing Art Gallery, Mr Francis Hawcroft and Mr Michael Clarke of the Whitworth Art Gallery, Mrs Jane Farrington of the Manchester City Art Gallery, the staff of the Royal Holloway College, especially Mrs New and Mr David Ward, Mr Godfrey Thompson of the Guildhall Art Gallery, and Miss Joan Pollard of the Museum of London.

Mr Rodney Omell and Mrs Barbara Isaacs of the N. R. Omell Gallery have been unfailingly helpful in finding suitable pictures and supplying photographs, and Mr and Mrs F. B. Cockett put their splendid collection of marine paintings at the disposal of the exhibition organisers. Of the many people who supplied information about particular pictures and marine painters we would like

especially to thank Dr David B. Brown of the Ashmolean Museum, Mrs Judy Aldrich, Miss Jeannie Chapel and Mr Kenneth Sharpe. We are also grateful to Mr John Taylor and Miss Charlotte Burri of Lund Humphries Publishers for their personal interest in the project and for the care and attention which they have devoted to the exhibition catalogue.

We must finally thank all those lenders who have kindly parted with their pictures and made this exhibition possible:

Her Majesty The Queen
Michael Appleby, Esquire
Bristol City Art Gallery
Mr and Mrs F. B. Cockett
Ferens Art Gallery, Kingston-upon-Hull
Lord Howick of Glendale
Guildhall Art Gallery, London
Laing Art Gallery, Newcastle-upon-Tyne
Manchester City Art Gallery
Museum of London
National Gallery, London
National Maritime Museum, Greenwich
Norfolk Museums Service
N. R. Omell Gallery
Royal Holloway College, Egham
Tate Gallery, London
Victoria and Albert Museum, London
Whitworth Art Gallery, Manchester

J. H. Morley
Director
Royal Pavilion, Art Gallery and Museums

Councillor D. J. Smith
Chairman
Amenities Committee

LIST OF ARTISTS

Figures in the introduction

Anonymous English woodcut (late 16th century) Fig.6
Brett, John, photograph Fig.2
Cooke, E.W., photograph Fig.1
Loutherbourg, P.J. de Fig.5
Lorrain, Claude Fig.3
Turner, J.M.W. Fig.7
Vernet, C.J. Fig.4

Numbers correspond to catalogue entries

Anderson, William (1757–1837) 35,36
Atkins, Samuel (fl. 1787–1808) 46,47
Austin, Samuel (1796–1834) 73
Beechey, R.B., Captain RN (1808–95) 82
Bentley, Charles (1805/06–54) 80,81
Bonington, R.P. (1802–28) 76
Brett, John (1830–1902) 92
Brooking, Charles (1723–59) 20, 21
Callcott, Augustus Wall (1779–1844) 56
Cappelle, Jan van de (1623/5–79) 5,6
Carmichael, John Wilson (1800–68) 75
Cleveley, John, the Elder (c.1712–77) 19 (+ colour plate II)
Cleveley, Robert (1747–1809) 32
Collins, William (1788–1847) 69
Constable, John (1776–1837) 52,53,54
Cooke, E.W. (1811–80) 86,87
Cotman, John Sell (1782–1842) 58,59
Cotman, Miles Edmund (1810–58) 83,84,85
Cox, David (1783–1859) 62,63,64
Drummond, Samuel (1765–1844) 41
Duncan, Edward (1803–82) 79
Fielding, A.V. Copley (1787–1855) 67, 68
Foster, Miles Birket (1825–99) 90 (+ colour plate VII), 91
Gore, Charles (1729–1806) 24,25
Hearne, Thomas (1744–1817) 31 (+ colour plate IV)
Hemy, Charles Napier (1841–1917) 93 (+ colour plate VIII), 94
Holman, Francis (fl. 1767–90) 44, 45
Huggins, William John (1781–1845) 57
Joy, William (1803–67) 77,78
Luny, Thomas (1759–1837) 37,38
Man, L.D. (fl. 1680–1710) 12
Monamy, Peter (c.1686–1749) 15,16
Nibbs, R.H. (1816–93) 89
Owen, Samuel (1768–1857) 42
Pocock, Nicholas (1740–1821) 27,28,29 (+ colour plate III), 30
Richardson, Thomas Miles, Sr (1784–1848) 65
Ruisdael, Jacob van (1628/9–82) 7
Sailmaker, Isaac (1633–1721) 13
Sailmaker, I., attributed to 14
Salmon, Robert (1775–1843(?)) 48 (+ colour plate V)
Schetky, J.C. (1778–1874) 55
Scott, Samuel (1701/02–72) 17,18
Serres, Dominic (1722–93) 22,23
Serres, John Thomas (1759–1825) 39
Sorgh, Hendrick (1611–70) 4
Stanfield, Clarkson (1793–1867) 70 (+ colour plate V), 71,72
Storck, Abraham (1644–1710) 11
Swaine, Francis (fl. 1761–82) 43
Turner, J.M.W. (1775–1851) 49,50,51
Van de Velde, Willem, the Elder (1611–93) 1,2,3
Van de Velde, Willem, the Younger (1633–1707) 8,9 (+ colour plate I), 10
Walter, Joseph (1783–1856) 60,61
Walters, Samuel (1811–82) 88
Ward, John (1798–1849) 74
Whitcombe, Thomas (c.1752–1827) 33,34
Wint, Peter de (1784–1849) 66
Wright, Richard (1735–75) 26
Wyllie, W.L. (1851–1931) 95
Yates, Thomas, Lt RN (c.1760–96) 40

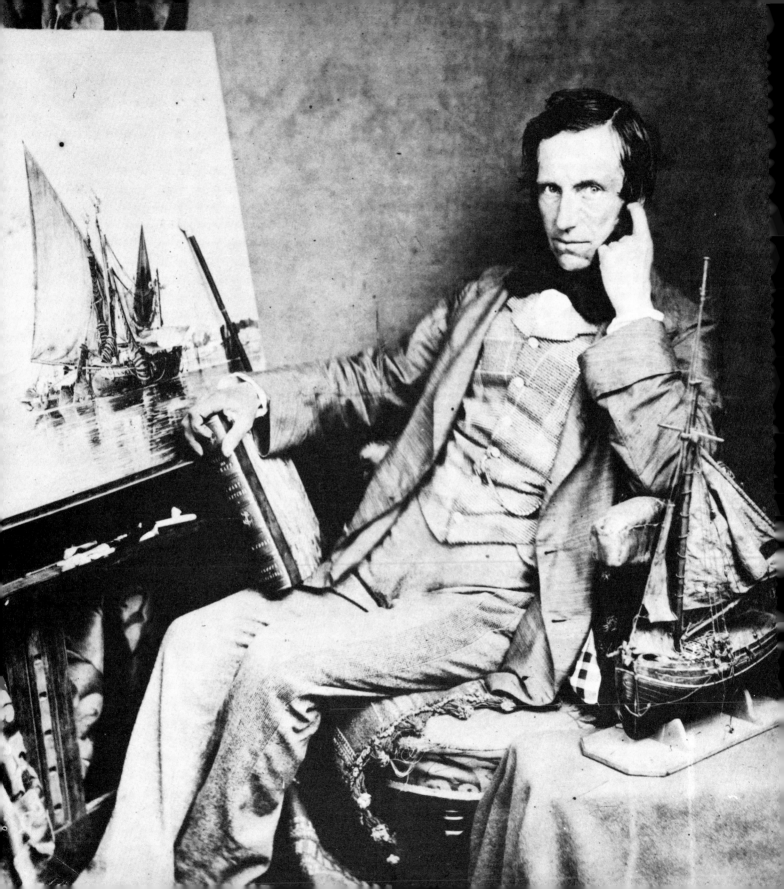

INTRODUCTION

Painting has taken many forms over the centuries, but of all the specialised subjects undertaken by artists few have been more demanding than seascapes, or what used to be called 'sea-pieces'. The depiction of architectural subjects was certainly difficult but could be mastered with the aid of a sound understanding of perspective. Portrait painting has always required special skills and the gift of capturing a likeness has eluded many artists; nevertheless the sitter could be studied at length, and the light in the studio was under the artist's control. And though the weather might change, the landscape artist could return to his subject again and again; he was, moreover, allowed some licence in the placing of trees and bushes, and might alter the balance of his composition by the introduction of a shepherd and his flock, or a few grazing cattle or deer. The painter of sea-pieces had no such advantages.

In the seventeenth and eighteenth centuries the demands on the marine artist were rigorous. Not only did he face the obvious difficulties of portraying water, but he was frequently commissioned to paint a particular moment in a particular sea battle. He must show the men-of-war in the correct positions in relation to each other; he must depict them with the appropriate sails set and the correct flags flying at the mastheads and from the yard-arms; he must pay attention to the exact state of the wind and tide. Since very few marine artists ever had the chance of witnessing a sea battle, the necessary information had to be supplied by the patron – who was usually a naval officer of some seniority.

The correspondence of Nicholas Pocock, who painted the battles of the Nelson era, is full of detailed instructions. A typical memorandum of 1805 begins, 'Sir Richard Strachan's compliments to Mr Pocock and inform him he just recollects that the French Admiral's mizen topmast should be shot away at the time the picture is meant to represent', and it is illustrated by a spiky little drawing of two ships in action. Many more examples could be found to show the accuracy demanded by naval patrons.

But having acquired the relevant facts about the action, the problems of the marine artist had only begun. Before the inventions of the Industrial Revolution, the fully-rigged three-masted sailing ship was the most complicated piece of machinery known to man. The shape of her hull, her gear and her fittings had evolved from the experience of several hundred years. Her rigging employed intricate systems of leverage and mechanics which took a seaman several years fully to understand. The masts of a 74-gun ship, for instance, were held in place by shrouds and stays employing some three miles of rope. The yards and sails were controlled by a system of braces, halliards and sheets involving over 1000 blocks or pulleys, and no less than eight miles of rope. While it was possible for a competent artist to portray the ship with some degree of accuracy as she lay at anchor, the situation changed entirely when she got under way. As the ship heeled before the wind, hundreds of ropes came into play. Of course many an artist was able to give a lively enough impression of a sailing ship at sea, but the seamen and shipowners who commissioned so many pictures wanted more than an impression.

In the circumstances it is not surprising to find that many marine artists came from a seafaring background. John Cleveley and William Anderson were former shipwrights. Dominic Serres, Pocock, Clarkson Stanfield and George Chambers

Fig. 1
Edward William Cooke in 1857
A splendid photographic portrait by Laker Price showing the distinguished Victorian marine artist at the age of forty-six. On his knee he proudly displays a bound volume of his etchings for *Shipping and Craft*. The ship model on the table beside him was the sort of studio prop much used by marine painters to help them when drawing the intricate details of gear and rigging. (See cat.86, 87)

were ex-seamen. J. W. Carmichael was apprenticed as a ship's carpenter, and John Ward's father was master of a brig. Those artists who had missed a nautical upbringing, made up for lost time by owning and sailing their own yachts: Schetky owned the *Wanderer*; the Cotman family owned the *Jessie*; Charles Gore designed a cutter called the *Snail* which was so successful that it influenced the design of naval cutters; and John Brett (Fig.2) bought a schooner which he sailed to the Channel Islands and round the Scottish coast with the help of a skipper and a crew of twelve. Nearly all serious marine artists also made much use of ship models (Fig.1) to help them with their paintings, and there are many instances recorded of this from the van de Veldes to Turner.

A knowledge of ships, and some experience of sailing, were helpful, but these alone could not produce a work of art – hence the hundreds of second-rate marine paintings which nowadays come up for sale in the sale-rooms, and the dozens of dreary ship portraits to be found on the walls of shipping companies and in the homes of seafaring families. If he was to rise above the level of a competent craftsman the marine artist must master those problems which have challenged every representational artist: the rendering of light; and the uniting of the different elements in the picture into a harmonious and satisfying composition.

Since the basic elements in most seascapes were limited to the sea, the sky and the ships, the artist had to use considerable ingenuity if he was to satisfy the traditional rules of composition. The different methods devised to achieve this purpose provide one of the most interesting aspects of marine painting. One

Fig.2
John Brett and his family on board his schooner *Viking* in 1883
Many English artists owned and sailed their own boats and used them as a base for drawing and painting expeditions. Brett was more ambitious than most and purchased a 210-ton schooner formerly owned by Baroness de Rothschild. Here he is photographed on the after deck, seated beside the captain, with his daughter Pansy on his knee. (See cat.92)

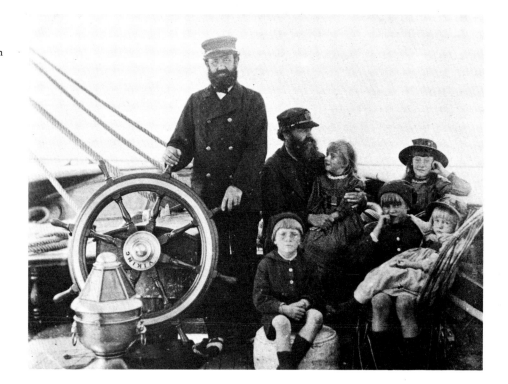

method, borrowed from landscape painting, was to make use of alternate bands of sunlight and shadow. The Dutch masters of the seventeenth century were particularly fond of introducing a strongly shadowed foreground which gave added drama to the sunlit sails of the shipping in the middle distance. The English artist Charles Brooking perfected a method of leading the eye into the picture and uniting the scattered sailing vessels with broad zig-zag shadows across the surface of the water. It was a device subsequently adopted by his associate Dominic Serres, and by Pocock and Whitcombe. The skilful juxtaposition of light and shadow on the surface of the sails was a favourite method of bringing drama to a composition and helping to balance the various elements in the picture.

A useful device for bringing interest to the foreground of a seascape was the introduction of a small boat. In the early Dutch pictures it was usually an open rowing boat from which one or two fishermen would be càsting a net – the curve of the net and its supporting corks giving further opportunities for variety. Later English artists also used the foreground boat to good effect. Indeed it is often possible to pin-point the exact locality of a picture by noting the particular local characteristics of the fishing boat portrayed: a Yorkshire coble, a Deal lugger and a Brighton hogboat were, for instance, unmistakable in their appearance. The small boat was not always simply decorative, however, but in many cases was a pilot boat engaged in the task of carrying a pilot out to a man-of-war or an East Indiaman approaching harbour.

Other devices for bringing interest to foregrounds included a large floating buoy, pieces of drifting wreckage and a scattering of seagulls. Some artists used these motifs with almost monotonous regularity. A device frequently employed to break up the dominating line of the horizon was a distant frigate, viewed broadside on so that her three masts could provide some vertical relief. The younger van de Velde was particularly fond of this motif and it was taken up by many English artists, including Turner who used it to good effect in the Bridgewater sea-piece, and *Sun rising through vapour*.

While an artist was often bound by the demands of his patron to paint the ships in a certain position, and to portray the sea affected by the prevailing weather conditions at the time, he was under no particular obligations with regard to the sky. Since the disposition of dark and light clouds provided a foil to the sails, and was a conveniently flexible means of altering the balance of the composition, it is common to find clouds used to good effect in seascapes and rare to find a marine painting with a clear blue sky. As the sky also set the mood for the entire picture and was the chief means for introducing a sense of atmosphere we find that the greatest painters of the sea from van de Velde to Monet were also masters at the art of painting skies.

The historical background

It is possible to find early examples of marine art in Greek vase paintings, Roman mosaic pavements, stained-glass windows and in the illustrations of medieval manuscripts, but the true sources of Dutch and English marine painting lie elsewhere. The origins are much the same as the origins of landscape painting – of

which marine painting is often considered to be a subsidiary branch. In certain fresco paintings in Italy in the fourteenth century, and among the historical and religious paintings of Italian artists such as Carpaccio in the fifteenth century, may be glimpsed the beginnings of marine painting. The legend of St Ursula provided an opportunity to paint embarkation scenes with moored ships, while the story of St Nicholas coming to the aid of shipwrecked sailors was a chance to paint ships in a storm.

Alongside the work of the Italians may be found examples of marine subjects by Flemish artists. Paul Bril, who was working in Rome in the 1580s, painted a number of picturesque harbour scenes. Of greater consequence was Pieter Breughel the Elder whose ships are depicted with a delicate accuracy and who painted a storm at sea with a foretaste of the atmosphere to be introduced centuries later by the artists of the Romantic movement. But it was the wonderful series of seaports painted by Claude Lorrain in the twelve years between 1636 and 1648 which were, perhaps, the first major landmarks in the development of marine art (Fig.3). Claude was no seaman. He had, it is true, experienced a Mediterranean storm while on a passage from Marseilles to Rome, and he had made many studies around the harbour at Naples, but the ships in his paintings, for all their beauty and intricacy, were fanciful reconstructions and could never have put to sea. Nevertheless his paintings of seaports were universally admired and had a considerable effect on the painting of certain types of marine subjects. A number of Dutch artists, notably Jan Baptist Weenix, Nicholaes Berchem and

Fig.3
Claude Lorrain:
Seaport
Oil on canvas, 99 × 129·2 cm / 39 × 51 in
Inscribed: CLAUDIO G.I.V ROMAE 1644
The National Gallery, London

The celebrated series of seaports and harbours which were painted by Claude between 1636 and 1648 had a lasting influence on a certain type of marine painting. The classical buildings at the water's edge, the morning or evening sunlight, and the numerous foreground figures appear in similar subjects by Dutch and English artists.

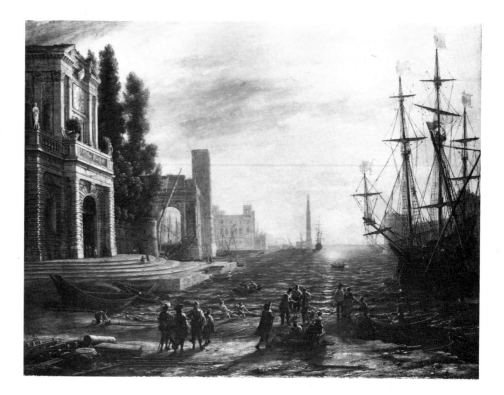

Fig.4
Claude Joseph Vernet:
A storm with a shipwreck
Oil on canvas, 88 × 138 cm/34$\frac{5}{8}$ × 58$\frac{3}{8}$ in
Inscribed: J. Vernet f.1754
The Wallace Collection, London

Vernet was the greatest marine painter of his
age. His pictures of shipwrecks and harbour
scenes were as admired in England as they were
in France, and many found their way into
British collections.

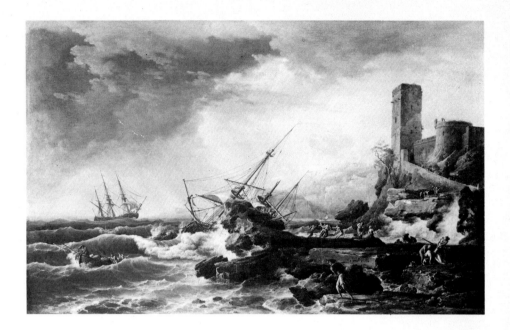

Abraham Storck, were inspired to paint imaginary harbours flanked by classical
buildings; the French marine artist Vernet was profoundly influenced by
Claude's achievement, and isolated examples occur in England, of which Turner's
Dido building Carthage is the most celebrated example.

While Claude was painting his seaports in Rome, a number of artists in the
Netherlands were concentrating all their attention on the depiction of the ships,
the small boats and the waterways of their native land. From the colourful coastal
scenes and embarkations of Adam Willaerts, from the sea battles of Vroom, and
from the grey, atmospheric estuary scenes of Simon de Vlieger and Jan Porcellis
was to develop a tradition of marine painting in Holland which was to reach its
highest point in the period between 1650 and 1700. The most distinguished
names were Aelbert Cuyp, Jan van Goyen, Jan van de Cappelle, and Willem van
de Velde the Younger. Marine subjects were only one aspect of the work of Cuyp
and van Goyen, but it was the beach scenes, and the sea-pieces of this group of
artists which was to have such an important influence on English marine painters
for more than a century and a half. Indeed it was not until Ruskin voiced the first
note of criticism in the mid-nineteenth century that enthusiasm for the Dutch
school began to wane, and a marine artist like John Brett was emboldened to write
of the revered van de Velde, 'his drawing of ships is very refined, firm, and
finished, but I am sorry to have to add that his clouds and sea show a degree of
ignorance that is very deplorable'.

For earlier English artists it was a different matter: Samuel Scott had a large
collection of van de Velde drawings and prints which were sold in several sales
after his death; the talented amateur artist Charles Gore appears to have taught
himself to draw chiefly by copying and by painting over the drawings of van de
Velde; while a sale of Nicholas Pocock's effects in 1821 included two of his copies

after van de Velde, and a copy of a painting by Jan van de Cappelle. The admiration of Constable, Turner and other Romantic artists for the Dutch school is well known and was thoroughly documented in Professor Bachrach's catalogue for the *Shock of Recognition* exhibition in 1971.

Second only to the Dutch in his effect on English marine art was Claude Joseph Vernet (Fig.4). The French artist was greatly admired in his own day for his paintings of seaports and shipwrecks, and the large number of engravings made after his work naturally helped to spread his fame abroad. The English engraver John Boydell was quoted by J. T. Smith as saying: 'In the course of one year I imported numerous impressions of Vernet's celebrated *Storm*, so admirably engraved by Lerpinière: for which I was obliged to pay in hard cash, as the French took none of our prints in return.' Richard Wilson, Robert Adam and Sir Joshua Reynolds met Vernet in Rome and were each impressed in different ways, while English gentlemen on the Grand Tour collected his pictures with enthusiasm. Vernet had a particularly characteristic approach to storm scenes: these depicted doomed sailing ships swept by the waves onto rocky shores, while frantic helpers on the beaches struggled to rescue survivors from the surf. He painted dozens of variations on this theme – which was particularly appropriate to the mood of the Romantic movement and its emphasis on man's helplessness before the awe-inspiring forces of nature. De Loutherbourg, who settled in London in 1771, was one of many artists working in England who based the style of his sea-pieces on that of Vernet. Two dramatic pictures in particular, *Smugglers landing in a storm* (Fig.5) and *Shipwreck with banditi* employ the same somewhat theatrical devices, and these in turn impressed a number of English artists at the time, including Pocock, J. T. Serres and Turner.

Fig.5
P. J. de Loutherbourg:
Smugglers landing in a storm
Oil on canvas, 106·7 × 160 cm/42½ × 63 in
Inscribed: P. I. de Loutherbourg 1791
The Victoria Art Gallery, Bath

A rocky inlet, with Conway Castle in the background, provides a setting of Gothick gloom for the sort of shipwreck theme much favoured by artists of the Romantic period.

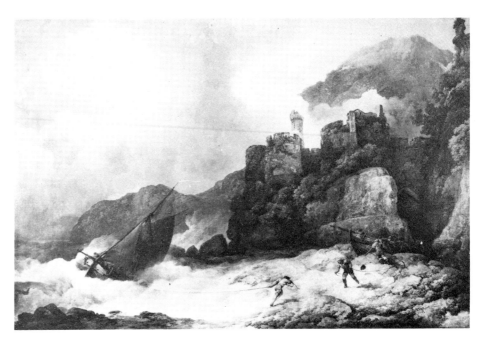

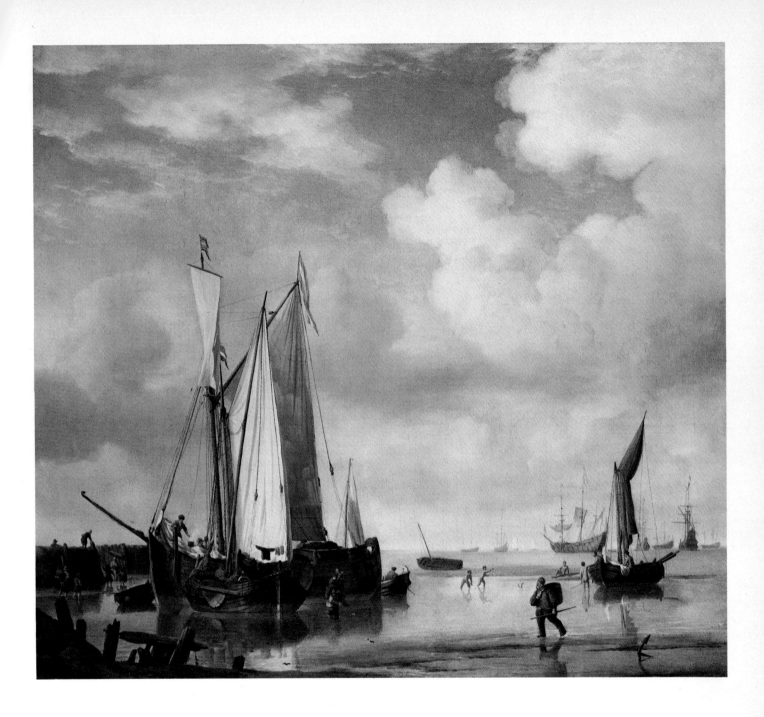

I
Willem van de Velde the Younger:
Dutch vessels close inshore at low tide, and
men bathing
See cat.9 + cover

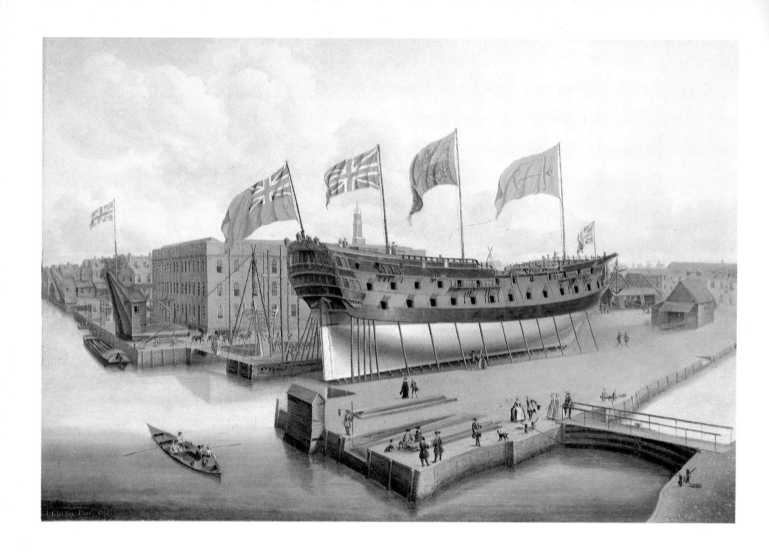

II
John Cleveley the Elder:
HMS *Buckingham* **on the stocks at**
Deptford
See cat.19

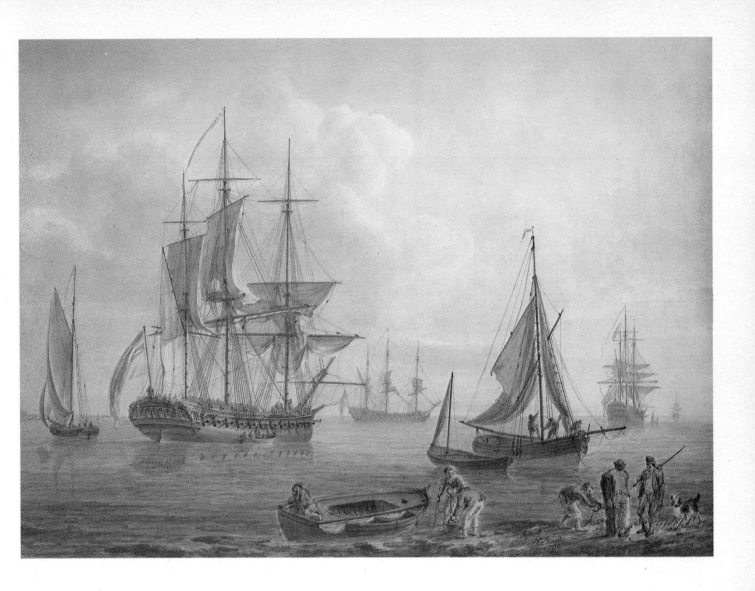

III
Nicholas Pocock:
The red squadron in a calm
See cat.29

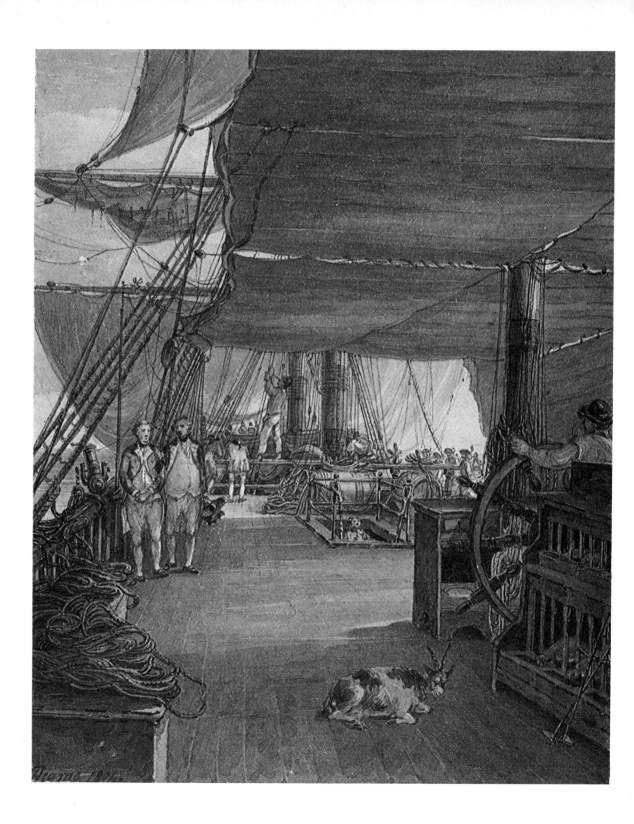

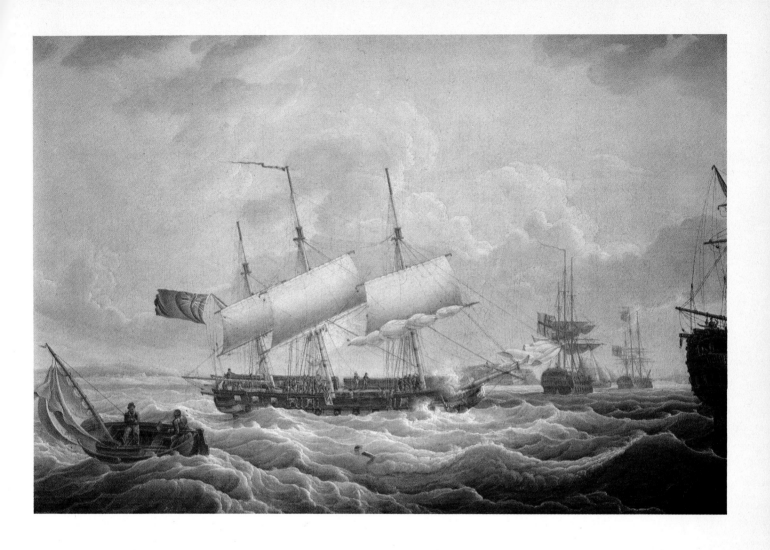

IV
Thomas Hearne:
A scene on board HMS *Deal Castle*
See cat.31

V
Robert Salmon:
A frigate coming to anchor in the Mersey
See cat.48

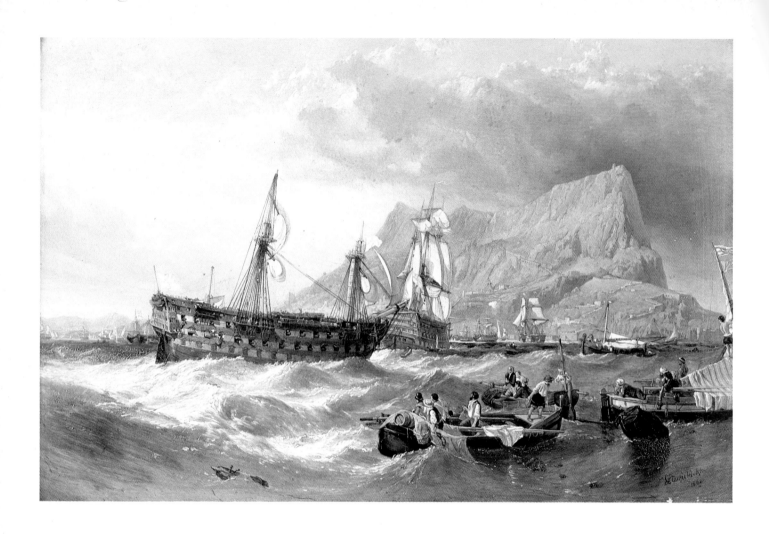

VI
Clarkson Stanfield:
The *Victory* towed into Gibraltar
See cat.70

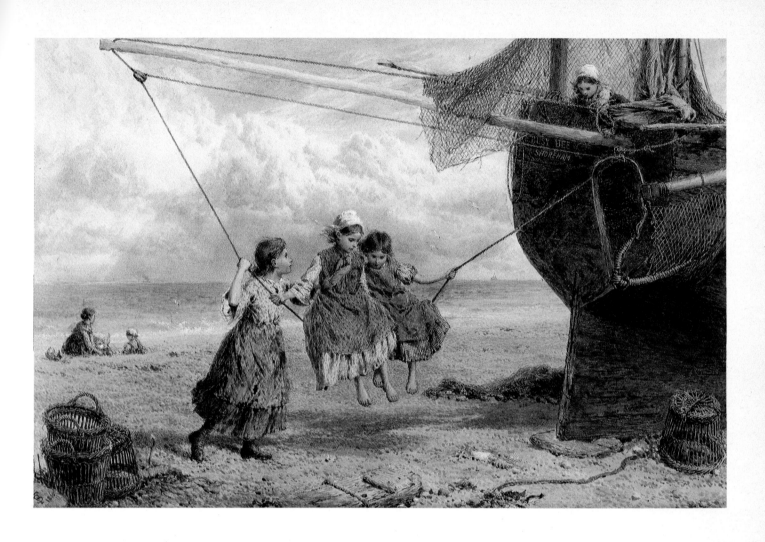

VII
Myles Birket Foster:
The swing
See cat.90

VIII
Charles Napier Hemy:
Among the shingle at Clovelly
See cat.93

Marine art in Britain

It would be a mistake to imagine that because so many foreign artists were admired and imitated in England, British marine painting had no character of its own. This is far from the case. Particular types of subject and certain methods of composition were certainly borrowed from Dutch and French artists, but they were adapted in a peculiarly British way. William Anderson, for instance, based his estuary scenes on the tranquil marines of van de Velde. He even included Dutch boats on many occasions. But with the literal-minded approach of so many British artists he had no hesitation in placing the shipping among the creeks and mud banks of the Thames and Medway. A soft misty light replaces the clear air of the Continent, and boats and foreshore are peopled by stolid, oafish-looking fishermen and their families.

A close interest in everyday activities, and all the detail of life in the docks and along the river banks, is a typical feature of many British paintings. We see it in the shipyard scenes of John Cleveley the Elder and Francis Holman. Indeed it is possible to build up a remarkably complete picture of life on the waterfront in the eighteenth century from their paintings. This interest in the more mundane aspects of the world around them finds a parallel in many paintings by British sporting artists. Just as the marine artists liked to portray fishermen and dockers at work, and took infinite pains over the drawing of rigging and gear, so we find John Wootton, Benjamin Marshall and John Ferneley Sr paying a similar regard to the fishing tackle and accessories of the angler, the shotgun and spaniels of the sportsman, and the horses and hounds of the huntsman. Rarely was any attempt made to create a heroic composition from these everyday activities. If the artist portrayed the sports and pastimes accurately, and captured a passable likeness of the owner, his horses and his dogs, then the artist and patron were perfectly satisfied – and exactly the same sentiment applied to the ship portrait.

Perhaps the most important contribution which British painters made to landscape and marine painting was the portrayal of 'atmosphere'. This word is often used but it is hard to define exactly what is meant by it. The English preoccupation with the weather has no doubt something to do with it. The heightened awareness of nature and the passing seasons which is so apparent in the work of English writers and poets is closely related to it. The rendering of light also contributes to the feeling of atmosphere in a picture, although this alone does not create it. In marine painting where the subject may be limited to sea, sky and two or three sailing vessels, the creation of atmosphere depended on acute observation, the skilful and sensitive use of colour, light and shadow, and a seaman's eye for the effect of the weather on waves and ships. Brooking and Whitcombe could convey the freshness and sparkle of a spring day in the Channel; Scott and Anderson were able, on occasions, to capture the stillness and peace of a warm summer evening on the Thames. Bonington and Constable portrayed the dazzling light associated with midday on the seafront in a manner only equalled by Boudin and Monet. Turner, for whom no effect of nature was beyond his grasp, encompassed with equal facility the rendering of seas stirred up by gale-force winds, and the golden light of sunrise on a calm river estuary.

Fig.6
The *Ark Royal*, flagship of Queen Elizabeth's navy
Anonymous English woodcut,
50 × 78·7 cm/20 × 29½ in
The British Museum, London

Until the later years of the seventeenth century marine art in Britain was mainly confined to manuscript illustrations, engravings and woodcuts. This decorative picture demonstrates the traditional English preoccupation with flat pattern-making.

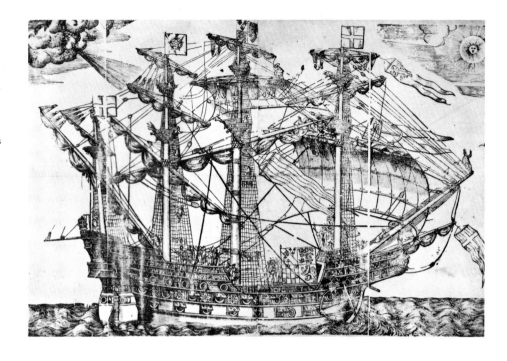

A feature of British art, often observed in other fields, but rarely commented on in marine painting, was a tendency to create flat patterns from the various elements in a composition. This feature has been traced back to Celtic designs and the intricate decorations of illuminated manuscripts; the illustrations of William Blake, and the early work of John Sell Cotman reveal a preoccupation with pattern-making, but it can be found in less obvious ways in many marine paintings. Perhaps this is not surprising because a ship in full sail provided an artist with every opportunity to exercise his decorative skills (Fig.6). The intricate criss-crossing of rigging, the cut of the sails, the flags and ensigns, the streaming pennants at the masthead, and the gilded carving of figure-heads and ships' sterns could be assembled into a complex network of shapes, colours and patterns. Robert Salmon's curiously individual style relies for much of its charm on the flat and decorative treatment of waves, flags and sails. The shipyard scenes of John Cleveley the Elder are notable for the bold manner in which the artist treats the ships on the stocks and the backdrop of cranes and warehouses. Above all it is the watercolours of marine subjects which demonstrate the skilfulness of British artists as designers. The greatest of the watercolour artists succeeded in combining a sense of atmosphere, a feeling of dampness in the air, with this skill, but in even the humblest work by obscure marine artists such as Samuel Atkins and Francis Swaine, the factual and documentary content of the picture is enlivened by the delicate drawing, and by the placing of the ships and small boats in a decorative manner.

The two-dimensional aspect of many British paintings is entirely different from the three-dimensional aspect of Dutch seventeenth-century sea-pieces. With van

de Cappelle and van de Velde we seem to be looking through an open window: the eye travels into the picture, beyond the ships to the horizon. The distance to the horizon seems infinite, and sea and sky melt into each other.

It is often said that art in Britain has been the work of isolated individuals rather than the cumulative results of schools of artists. This may perhaps be the case with landscape painting in Britain, but it is not the case with marine painting. There is without doubt a tradition of marine art which justifies the use of the term 'the British school of marine painting'. The school is held together by a common allegiance to van de Velde the Younger, but it also depends to a surprising extent on the handing down of traditions in an almost unbroken succession of personal contacts between artists. There are numerous instances of sons taking over the 'family business' of marine painting from their fathers, and there are many instances of young artists being pupils – or certainly being associates – of older, more established artists.

The chain of succession begins, of course, with the elder van de Velde passing his skills on to his son, van de Velde the Younger. He, in turn, became the centre of a group of marine artists in London which included his own son Cornelius van de Velde, and van de Hagen, L. D. Man, and the Englishman Robert Woodcock. Before the death of Willem van de Velde the Younger at Westminster in 1707, Peter Monamy had come to London. He was apprenticed in 1696 and became a Freeman of the Painter Stainers Company in 1703. He may not have met van de Velde but he certainly copied his work assiduously, and incidentally he also spent the latter part of his life at Westminster. There is a tradition that Francis Swaine was a pupil of Monamy and the fact that he christened his son Monamy Swaine would seem to confirm this link.

Overlapping Monamy and Swaine were the Cleveley family. John Cleveley the Elder, born in 1712, had three sons, and two of them, Robert and John, both became marine artists. The gifted marine artist Charles Brooking had both a direct and indirect influence on the development of marine art in Britain. Edward Edwards records that Dominic Serres 'knew Brooking well' and many compositional devices used by Serres make it clear that he must have copied Brooking as a young artist. Among Nicholas Pocock's many sketchbooks are several drawings after Brooking (inscribed as such), while traces of Brooking's techniques may also be found in the work of Thomas Whitcombe.

The next father and son team was that of Dominic Serres and his son John Thomas Serres. Together they wrote a book of instruction for marine artists, and J. T. Serres even took over for a while the post of marine painter to the King. Other examples of father and son working as marine artists include: Nicholas Pocock and his son Lieutenant William Innes Pocock; the Cotman family; Clarkson Stanfield and his son George; Miles Walters and his son Samuel; and the Cooke family of which E. W. Cooke was the most distinguished, but whose father and uncle were both successful engravers of the work of many of the marine artists of the day.

The unifying influence of van de Velde on the work of the eighteenth-century marine artists, was to a large extent replaced by the unifying inspiration of Turner's sea-pieces in the nineteenth century (Fig.7). Callcott was a close

disciple, but the influence of Turner on William Daniell, Cotman, Stanfield and E. W. Cooke can be documented equally well.

For two centuries the closest links were maintained among marine artists. They exhibited side by side at the Society of Artists, at the Royal Academy and at the exhibitions of the various watercolour societies. They met socially, and they imitated each other's work. Above all they were united by the expertise demanded by their exacting profession.

It would be foolish to pretend, as some have done, that the art of marine painting reached its highest point in England. Indeed a parallel has often been drawn between the rise of marine painting in this country and the growing supremacy of British sea power in the eighteenth century. The ability to win a sea battle had nothing whatsoever to do with the ability to portray that battle as a work of art. The fact that Britain has produced more than her fair share of naval commanders of genius does not mean that she has likewise produced an equivalent number of gifted painters. There is no doubt that the victories of Rodney, Hood, Jervis and Nelson created a ready market for sea-pieces, and competent artists were there to fill this demand, but in all honesty it must be admitted that with a few notable exceptions much of their work pales into insignificance when set beside the achievements of the Dutch seventeenth-century masters, or the marvellous sea paintings of Courbet, Boudin and Monet. Nevertheless there are a number of minor masters in the British school of marine painting whose work has considerable charm.

To this may be added the virtues of good craftsmanship, honesty of purpose, and the occasional touch of poetry. If we set beside the minor masters, the massive contribution of Turner, and the beach scenes of Constable and Bonington, the overall achievement is impressive. It may not be as spectacular as the victories of Lord Nelson, but there is no reason to be ashamed of the sea painters of Britain.

Fig.7
J. M. W. Turner:
The *Victory* returning from Trafalgar
Oil on canvas, 57 × 95 cm/26⅜ × 37⅜ in
From the collection of Mr and Mrs Paul Mellon

In the first decade of the nineteenth century Turner painted a series of masterly seascapes which caused a stir among the art critics and connoisseurs. These paintings were greatly admired by the younger artists of the day and Turner rapidly replaced van de Velde as the major influence on British marine artists.

THE DUTCH MASTERS

There can be no doubt about the extraordinary influence of Dutch seascapes on several generations of British marine artists. Apart from obvious similarities in composition and subject matter, there are many instances recorded of British artists collecting the work of the Dutch masters, and well documented examples of British artists making careful copies of the work of van de Velde, Ruisdael, and van de Cappelle.

There is a simple explanation for this phenomenon. Towards the end of 1672 Willem van de Velde the Elder, and his son Willem van de Velde the Younger emigrated to England. The exact date of their arrival is not certain, which is a pity because this date could be regarded as the beginning of marine painting in this country. The two men were acknowledged as the supreme masters of their craft, and Charles II welcomed their arrival with enthusiasm. On 12 January 1674 a Royal Warrant was issued which ordered the Treasurer of the Navy to pay 'the Salary of One hundred pounds p. Annm unto William van de Velde the Elder for taking and making Draughts of seafights, and the like Salary of One hundred pounds p. Annm unto William van de Velde the Younger for putting the said Draughts into Colours for our particular use'.

The van de Veldes were provided with the use of a studio in the Queen's House at Greenwich (believed to be a room on the south-west side), and they took up residence in a house in East Lane, Greenwich. They later moved to a house in Westminster. Father and son were immensely industrious and the King certainly obtained good value from the salaries which he paid them. In addition to sea battles they painted ship portraits, the fleet at sea, and numerous pictures of royal embarkations and arrivals. Other Dutch artists, and some of their relatives, joined them in London and there was soon a veritable factory of marine art in existence.

For English artists the importance of the van de Veldes lay not only in the personal skills of the two artists themselves but in the fact that they brought with them the traditions and techniques of what has come to be known as the golden age of Dutch art. It was the age which produced Rembrandt, Vermeer, Frans Hals, as well as van Goyen, Ruisdael, Cuyp, van de Cappelle and the other great masters of the landscape and the seascape.

In the circumstances it was not surprising that the artists already working in Britain should be somewhat overwhelmed by this invasion from Holland. As Vertue wrote of Isaac Sailmaker, 'his contemporaries the Vander Veldes were too mighty for him to cope with'. Eventually the more gifted English artists began to adapt the Dutch models to suit their own style, and gradually broke away from slavish imitations. But the Dutch influence nevertheless persisted for a century or more, and for this reason it is important to look at some examples of Dutch seascapes before examining the work of the British school.

Willem van de Velde the Elder
1611–1693

I

The first battle of Schooneveld, 28 May 1673

Grisaille, on canvas, 49·5 × 76·2 cm / 19½ × 30 in
Inscribed: W. V. Velde f.1684/oudt. 73 Jaren
The National Maritime Museum, London

It is appropriate that a survey of English marine art should begin with this work, which was painted ten years after the van de Veldes settled in England and were given a Royal Warrant 'for taking and making Draughts of seafights'. Van de Velde the Elder was the acknowledged master of the *grisaille*, and he used the delicacy of the monochrome technique to describe every detail of ships and sea battles as can be clearly seen here. That he took some pride in this particular picture is indicated by the note he inscribed after his signature which records that he was aged 73 years. The curiously high vantage point was frequently adopted by the early Dutch masters; later English artists such as Pocock and Serres found the panoramic view equally useful for portraying the complicated manœuvres of a fleet action.

The Schooneveld was a narrow basin at the mouth of the river Scheldt. It was the scene of two fierce engagements between the Dutch fleet under De Ruyter and the combined English and French fleets during the Third Dutch War. The first battle commenced at noon on 28 May 1673 when Prince Rupert led the Allies into attack. The action lasted nine hours at the end of which De Ruyter forced the Allies to withdraw with the loss of two French ships. There is an oil painting of the Second Battle of Schooneveld, also by van de Velde the Elder, in the National Maritime Museum.

2, 3
**Two studies of the Dutch fleet during the
expedition from Texel to the Sound in 1658**
2 Grey wash, 28·6 × 96·5 cm / 11¼ × 38 in
3 Grey wash, 27·9 × 102·9 cm / 11 × 40½ in
The Royal Pavilion, Art Gallery and Museums,
Brighton

Willem van de Velde the Elder was the son of a
sea captain, and was himself often at sea during
the 1640s and 1650s. The evidence shows that
he was present with the Dutch fleet on
numerous occasions and often had himself
rowed among the ships during the course of a
battle while he made drawings of the action. He
had his own boat for this purpose, a *galliot*, and
in one report to the Dutch government he
described himself as 'Draughtsman to the fleet'.
The battle of the Sound took place on

29 October 1658 and was fought between the
Swedish fleet and a combined force of Dutch
and Danish ships off the coast of Denmark. One
of Holland's naval heroes, Vice-Admiral de
Witte, was killed during the action and his
flagship sunk. These two drawings are typical of
the sketches van de Velde made at sea, and the
low viewpoint would certainly suggest that they
were made from a small boat. It would be
tempting to say that they depict the battle in
progress, but in fact the Dutch fleet is shown at
anchor and the smoke is from guns firing a
salute. In the National Maritime Museum there
is a painting in *grisaille* by van de Velde the
Elder which shows the battle at its height.

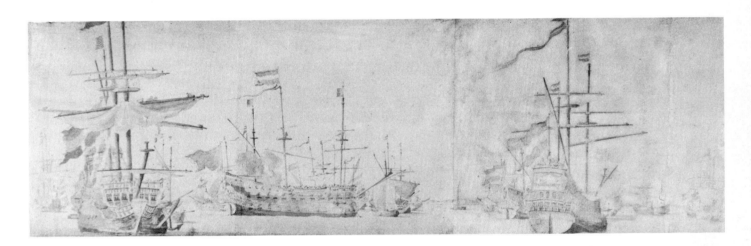

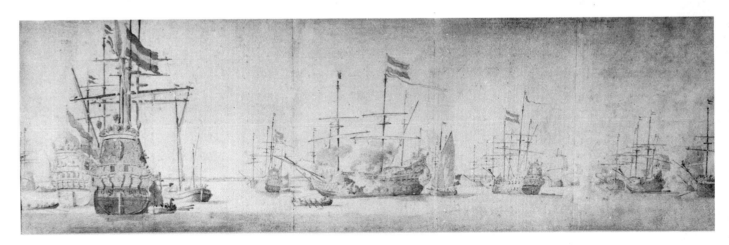

Hendrick Sorgh 1611–1670

4
Dutch vessels in a fresh breeze
Oil on canvas, 58·4 × 83·8 cm / 23 × 33 in
Inscribed: HMS (monogram) 1664
Mr and Mrs F. B. Cockett

Seascapes by this interesting artist are rare, and
this picture represents an important type of
Dutch marine painting which would otherwise
be missing from this survey. Two of the most
formative influences on the development of sea
painting were Jan Porcellis and Simon de
Vlieger. They changed the mood and subject
matter from cheerful, brightly-coloured
embarkation scenes to windswept estuaries
scattered with heeling sails and overshadowed
by scudding clouds. Their work was
characterised by a restricted palette of cool
colours, with silvery greys predominating. Van
de Velde the Younger was a pupil of Simon de
Vlieger and so was particularly influenced by his
work, but this painting by Sorgh is also typical
of the de Vlieger tradition.

Hendrick Martensz Sorgh was a native of
Rotterdam and the son of a cargo-boat captain.
In 1659 he was Chairman of the Rotterdam
Guild. Most of his paintings are of market
scenes and peasant interiors, but those of his
seascapes which are known clearly demonstrate
his knowledge of shipping. One of his finest
marines is in the Rijksmuseum and is entitled
Storm on the Maas with fishing vessels.

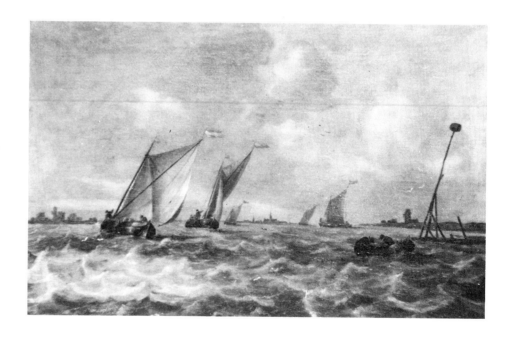

Jan van de Cappelle c. 1626-1679

5
A river scene with many Dutch vessels becalmed

Oil on canvas, 111·8 × 153·6 cm / 44 × 60½ in
The National Gallery, London

This serene work by one of the greatest of all marine artists typifies the achievement of the Dutch school. A miscellaneous collection of vessels including a haybarge, a ferry, a yacht and various fishing boats are scattered among mud banks in an almost featureless expanse of shallow water. Worn, patched sails are drying in the sun, washing is hung out to air and a careful examination reveals the details of everyday life afloat. From this humble raw material the artist has created a harmonious composition on a grand scale. The placing of the groups of vessels, the pattern of light and shade on the sails, and the careful disposition of diagonal spars, posts and flags is masterly. An extraordinary illusion of depth is created so that the foreground melts imperceptibly into the distance, and the horizon vanishes into the sky. To this characteristic Dutch achievement, van de Cappelle has brought an additional gift: an ability to fill the picture with light and with what Stechow has described as 'an atmosphere of an almost palpable moisture such as had never been painted before'.

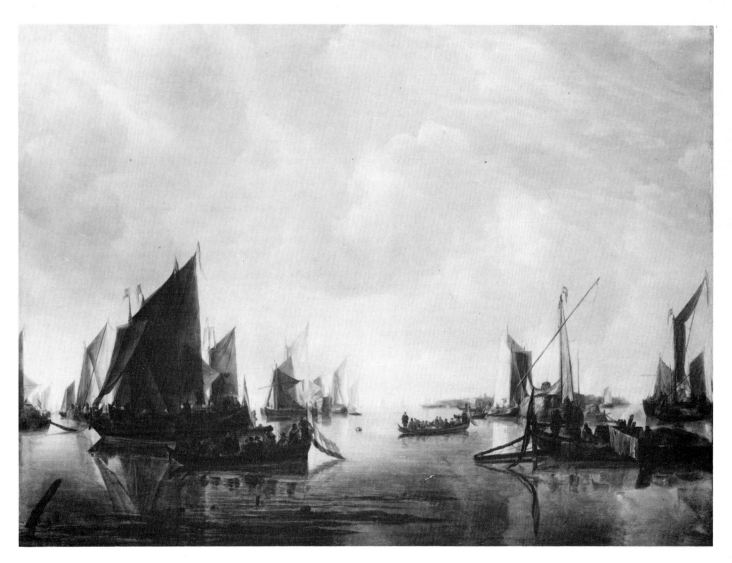

6
A small Dutch vessel before a light breeze
Oil on canvas, $44 \cdot 3 \times 55 \cdot 6$ cm / $17\frac{7}{16} \times 21\frac{7}{8}$ in
The National Gallery, London
(*not reproduced*)

Although better known for his larger canvases depicting numerous vessels at anchor in mirror-calm waters, van de Cappelle also painted some breezy estuary scenes. The cool, grey colours of this picture are reminiscent of Simon de Vlieger, whose work he is known to have copied. The paintings of van de Cappelle are given an added value by the fact that they are comparatively rare. No more than 200 of his pictures are known, fifty of these being winter landscapes and the remainder of them marines. Van de Cappelle had no need to paint for a living because he inherited a dye-works from his father and became a successful and wealthy industrialist. He owned his own yacht and established one of the greatest art collections of his time: it included 500 Rembrandt drawings, 10 paintings and 400 drawings by van Goyen. It is usually considered that Cuyp, Ruisdael, and the younger van de Velde had the greatest influence on later generations of English landscape and marine artists, but it is interesting to note that a sale of Nicholas Pocock's work after his death in 1821 included a 'Copy of a painting by Capelle, originally in possession and much valued by Sir J. Reynolds'.

Jacob van Ruisdael 1628/29-1682

Willem van de Velde the Younger 1633-1707

7
Vessels in a fresh breeze
Oil on canvas, $45 \cdot 1 \times 54 \cdot 6$ cm / $17\frac{3}{4} \times 21\frac{1}{2}$ in v
Inscribed: JvRuifdael
The National Gallery, London

Although better known for his panoramic landscapes, his waterfalls and his woodland scenes, Ruisdael painted some forty seascapes and a number of beach scenes. Almost all his seascapes depict storms at sea, or overcast, windy days on river estuaries. Perhaps the most celebrated of his marine paintings is the *Rough sea* in the Boston Museum, and there is the equally dramatic *Stormy sea* in the National Museum, Stockholm. Ruisdael developed a characteristic and peculiarly effective method of portraying the spray and whipped-up waves of shallow waters. This skill, together with the dark shadows cast across the foregrounds and the soaring grey clouds, give his seascapes a haunting and melancholy grandeur. Constable, who seems to have admired Ruisdael above all other artists, wrote that 'whenever he attempted marine subjects, he is far beyond Vandervelde'.

The younger van de Velde was the most versatile, the most admired and the most influential of marine painters. When he died in Westminster at the age of seventy-four he had portrayed all the major sea battles of the period and depicted virtually every type of vessel afloat in the waters of north-west Europe. The collections at Greenwich alone contain several hundred of his drawings as well as sixteen paintings, and there are numerous examples of his work in museums in London and Holland, as well as in country-houses throughout England. When he and his father took up residence in Greenwich in 1673, they became the centre of a school of followers and imitators. Art historians are still trying to identify the various Dutch and English artists who were painting sea-pieces in the style of the younger van de Velde during the first two decades of the eighteenth century.

In his own day, van de Velde was chiefly admired for the accuracy of his ship drawing and his pictures were valued as documentary records. Later generations, and particularly the English artists of the Romantic period, admired his ability to portray the sea and sky in all conditions of wind and weather. Turner regarded Claude and van de Velde as his greatest rivals. Early in his career he set out to challenge the Dutch master's supremacy as a marine artist. His *Dutch boats in a gale* of 1801, which was commissioned by the Duke of Bridgewater as a pendant, or companion piece, to *A rising gale* by van de Velde, was one of his many attempts to

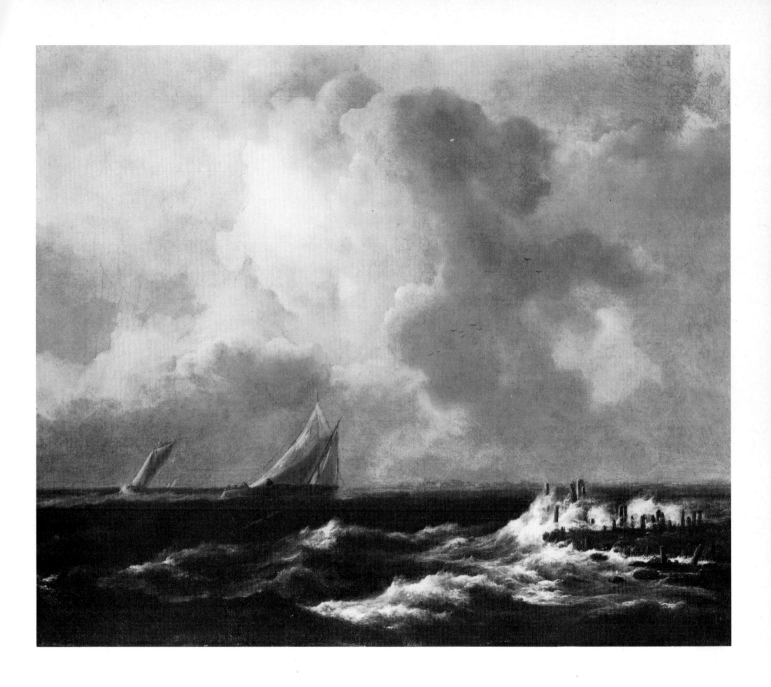

prove that he was the greater artist. Constable never ceased to acknowledge his debt to the Dutch school: 'Change of weather and effect will always afford variety' he wrote in 1824. 'What if Vander Velde had quitted his sea pieces, or Ruysdael his waterfalls, or Hobbema his native woods. The world would have lost so many features in art.'

8
A Dutch yacht, surrounded by many small vessels, saluting as two barges pull alongside
Oil on canvas, 89·9 × 126 cm / $35\frac{3}{8}$ × $49\frac{5}{8}$ in
Inscribed: WVV; (and indistinctly in two places) ANNO 16 (...)/ANNO 1(6)61
The National Gallery, London

Paintings like this have provided maritime historians with a mass of information about the ships and small craft of the late seventeenth century. Both van de Velde and his father studied ships from all angles and made hundreds of detailed drawings in pen and wash. It is also recorded in Roger de Pile's *Art of Painting* that the elder van de Velde 'for his better information in this way of Painting had a Model of the Mast and Tackle of a Ship before him, to that nicely and exactness that nothing was wanting in it, nor nothing unproportionable. The Model is still in the hands of his Son.' It is possible that a specific event is commemorated in this picture. (It could represent an occasion in 1660 when Charles II made a voyage from Moerdijk to Delft, before setting off for

England.) However, it is more likely to be an imaginary scene, giving van de Velde an opportunity to demonstrate his virtuoso skill at depicting Dutch craft. On the right of the picture is a beautiful *boeier* yacht with a white flag at her masthead, and a pennant at her stern on which the artist has inscribed his initials WVV. The sailing vessel with the elaborately carved stern in the centre of the picture is a States yacht. She is flying the Dutch ensign and on her stern are the arms of the Province of Holland.

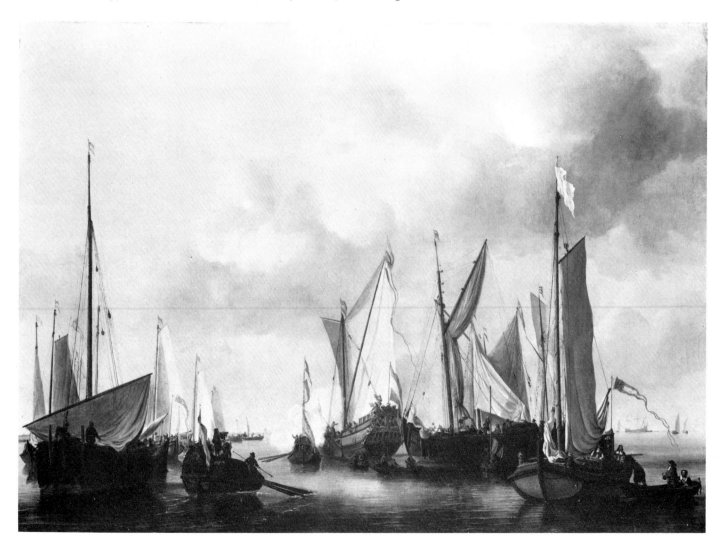

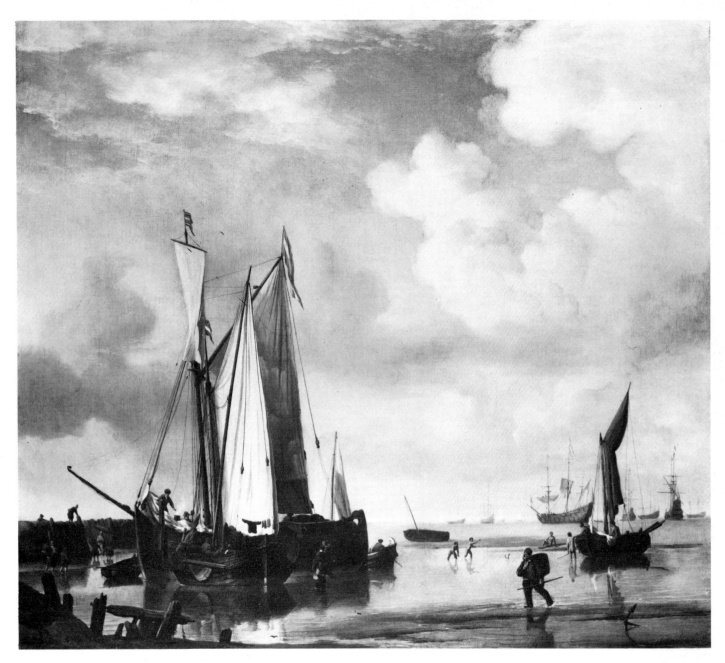

9
Dutch vessels close inshore at low tide, and men bathing
Oil on canvas, 63·2 × 72 cm / $24\frac{7}{8}$ × $28\frac{3}{8}$ in
Inscribed: WV Velde 1661
The National Gallery, London
(*colour plate* 1 + *cover*)

This is one of the finest of all van de Velde's tranquil marines. The clarity of light, the brilliance of colour, and the beautiful drawing of the boats and their gear make it easy to understand how this artist gained his high reputation. Although his work embraced every type of marine subject from sea battles and

storms to ship portraits and royal embarkations, it was his peaceful river and estuary scenes which were most admired and sought after by collectors and connoisseurs. For more than a hundred and fifty years after the death of van de Velde, English artists were producing variations on themes such as this. Some paintings, like

William Anderson's pictures of shipping on the Medway, have a naïve charm of their own. Later Victorian artists such as Stanfield and E. W. Cooke went to considerable pains to study the characteristic hull forms of Dutch boats, and drew them with impressive accuracy. But it has to be said that most of the English pictures were pale imitations. Only Turner truly succeeded in rendering reflections and capturing the elusive quality of light at the water's edge with the skill of van de Velde.

10
The Royal Escape
Oil on canvas, 63·5 × 76·2 cm / 25 × 30 in
Inscribed: W V V
Her Majesty Queen Elizabeth II
(*not reproduced*)

Six weeks after his defeat by Cromwell at the Battle of Worcester in 1651, King Charles II arrived secretly at Brighton. He stayed in rooms at the George Inn in West Street while negotiations were carried out with Captain Nicholas Tettersell, the owner of a coal brig called *Surprise*. At two o'clock in the morning the King and Lord Wilmot went on board the *Surprise* which was lying aground on the beach at Shoreham. Captain Tettersell gathered together a crew of four men and a boy, and as soon as the tide floated them off, they set sail for France. They put into Fécamp on the coast of Normandy and the King went ashore to begin his nine years of exile. When Charles II was restored to the throne in 1660, Captain Tettersell sailed the former coal brig up the Thames and moored her opposite Whitehall Palace. She was renamed *The Royal Escape*, fitted up with a smack rig, and taken into the King's service as a royal yacht. Tettersell was given a pension of £100 a year and taken on as captain of the yacht.

In his official capacity as marine painter to the King, van de Velde painted several commemorative pictures – including one (now in the Wallace Collection) which depicts the King's triumphal return from the Continent and is entitled *The embarkation of Charles II at Scheveningen, 1660*. It is presumed that this picture of *The Royal Escape* was commissioned by Charles II himself. It was recorded as being in the collection of James II where it was described as, 'A Little sea piece, with the bark in it, that carried the King to France'.

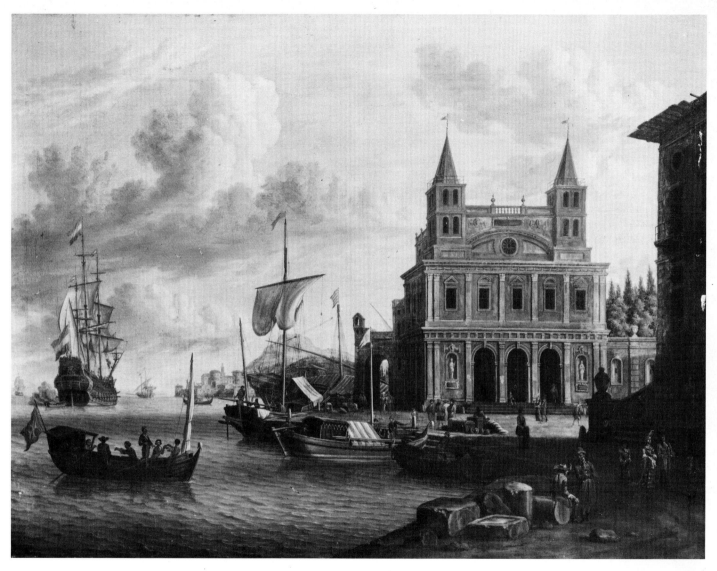

Abraham Storck 1644–1710

11
An imaginary harbour scene
Oil on canvas, 90·2 × 119·4 cm / 35½ × 47 in
The Royal Pavilion, Art Gallery and Museums,
Brighton

With the departure of the van de Veldes to
England in 1673, Abraham Storck and Ludolf
Bakhuizen (1631–1708) took over their role as
the leading marine painters of Holland. Storck,
who was the son of a painter, was born in
Amsterdam and appears to have lived all his life
in the city. He painted sea battles and harbour
scenes, and although he lacked the talents of van

de Cappelle and van de Velde, his finest work is
bright, colourful and very decorative.

 This painting is of particular interest because
it is plainly inspired by the celebrated seaport
paintings of Claude Lorrain. In particular the
composition closely resembles Claude's *Sunset
with the Villa Medici*, in the Uffizi Gallery. A
comparison of the various architectural features
in the two paintings shows similarities which
cannot be accidental, and it is likely that Storck
took his inspiration from an engraving. *Sunset
with the Villa Medici* was engraved by
Dominique Barrière in 1660.

L. D. Man fl. 1680–1710

12

Dutch shipping in an estuary
Oil on wood panel, 35 × 48·9 cm / 13¾ × 19¼ in
Inscribed: L. d. Man
Mr and Mrs F. B. Cockett

L. D. Man is one of half a dozen marine artists whose work is associated with the English period of van de Velde the Younger. In common with Jacob Knyff, J. van de Hagen and Cornelis van de Velde, who were also known to be working in London around 1700, L. D. Man painted ship portraits and other marine subjects in the manner of van de Velde, and in the past his work has sometimes been confused with that of the Dutch master. In fact L. D. Man had a distinctive style of his own which has become increasingly apparent as more signed paintings from his hand have come to light. His ships are drawn with careful precision and much attention to detail, and the warm pinkish tones pervading this peaceful estuary scene are particularly characteristic. As in the case of the mysterious H. Vale and R. Vale of the same period, nothing whatsoever is known about his life. His signature is sometimes L. D. Man and sometimes L. de Man and the name suggests that he may have been of Dutch origin.

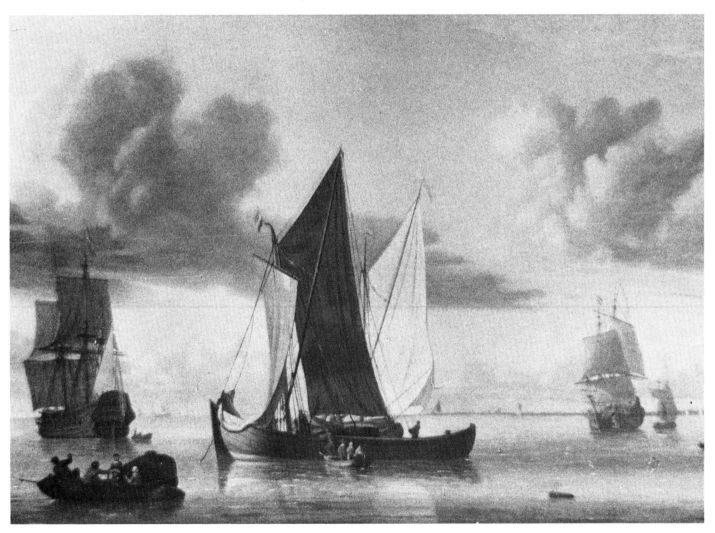

Isaac Sailmaker 1633–1721

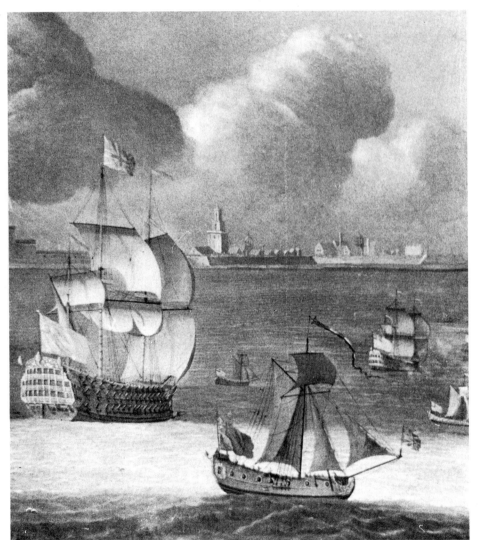

13
A first-rate ship and an Admiralty yacht off Portsmouth
Oil on canvas, 85·7 × 77·7 cm / $33\frac{3}{4}$ × $30\frac{5}{8}$ in
Mr and Mrs F. B. Cockett

Although he has sometimes been regarded as one of the founders of the English school of marine painting, Isaac Sailmaker must more properly be classed among the group of followers of the van de Veldes in London. His apparently English surname is more likely to have been an anglicised version of the Dutch 'Sailmacker' or 'Zeilmaker'. There is an interesting account of him in George Vertue's *Notebooks*. Vertue notes that 'he was born at Scheveling came very young into England and always liv'd here. & died here at his home near the Riverside without the Temple Gate call'd the Kings bench Walks'. No signed paintings by Sailmaker have yet come to light and most of the paintings assigned to him have been attributed on the basis of engravings after his work. However this decorative painting of shipping off Portsmouth does seem to bear the hall marks of his style. Judy Aldrich, who has made a study of Sailmaker and the other marine artists of this period, considers that this picture belongs to that category of paintings most likely to be by Sailmaker: 'the date is right, the ship is English and the artist's style does not tally with any other of the known artists working at the time'.

Attributed to Isaac Sailmaker

14
The battle of Malaga, 13 August 1704
Oil on canvas, 39·4 × 52·1 cm / $15\frac{1}{2}$ × $20\frac{1}{2}$ in
The National Maritime Museum, London
(*not reproduced*)

The attribution of this rather primitive painting to Sailmaker is made on the basis of its similarity to a large engraving of the same battle which is inscribed 'Sylmaker Delin'. The National Maritime Museum has an example of the engraving, and it is entitled *A SEA FIGHT between Her Majesties Royal Fleet commanded by the Right Honble. Sr. Geor : Rooke Vice Admiral of England &c. and the French commanded by the Count de Tholouse in the Mediterranean*. The battle of Malaga was a crucial engagement during the War of the Spanish Succession. Although the battle itself was indecisive and neither side lost a ship, the casualties were heavy, and it put an end to the Franco-Spanish attempt to capture Gibraltar. Whatever the attribution of the painting may be, it is typical of many early attempts to portray sea battles. The high horizon, the panoramic view and the colourful emphasis on flags and ensigns are very characteristic.

THE BRITISH SCHOOL

Just as Holland proved a fruitful place for marine artists in the seventeenth century, so England provided favourable conditions for the development of marine art in the eighteenth century. A succession of wars, in which sea battles played a prominent part, helped to focus the attention of the British people on the ships and seamen of the Royal Navy. Pictures of naval actions were much in demand and those artists who were able to carry out such commissions were never short of work. A few marine artists, particularly those whose paintings were engraved and published in large numbers, were able to make a very good living. There was also a demand for pictures of merchant shipping. The growing fortunes of the East India Company were reflected in countless commissions for ship portraits of the company's ships. But it was not only the ships which attracted the attention of the artists. The busy harbours of Bristol and Liverpool, the naval docks at Portsmouth and Chatham, and the shipyards along the banks of the Thames also provided a variety of nautical subjects.

Yet in spite of the steady demand for pictures, marine painting in Britain remained a minor art form throughout the eighteenth century. While portraits and history pictures dominated the walls of the Royal Academy, marine painting was almost exclusively patronised by naval officers, shipmasters and shipowners. It was practised by a small band of professional marine artists most of whom were former sailors or shipwrights, and few of whom attained eminence in their profession. The only marine artist who achieved notable worldly success was Dominic Serres. A founder member of the Royal Academy and for a time its Librarian, he was also appointed Marine Painter to George III and acquired a luxurious house in Hyde Park, but it has to be noted that he was a Frenchman by birth, and though a competent artist, was not in the same class as Gainsborough, Reynolds, Wilson, Stubbs and the other artists working in Georgian England.

It was not until the end of the eighteenth century that seascapes became an acceptable subject for artists who were not former seamen. In 1795 de Loutherbourg, who had no seafaring background, exhibited a vast and dramatic canvas at the Royal Academy depicting the Battle of the Glorious First of June. It proved a popular success, and he followed it with two paintings of a similarly heroic nature depicting the Battles of Camperdown and the Nile. In 1801 Turner exhibited *Dutch boats in a gale* which caused an even greater sensation, and during the next few years he painted a series of equally impressive marine paintings including the celebrated *Shipwreck* of 1805. Lesser artists followed suit and a considerable proportion of the hanging space at Somerset House was soon occupied by coastal views, storms and sea battles.

The spectacular victories of Nelson, Duncan, Rodney and Hood were obviously responsible in large measure for the interest in ships and naval actions, but there was also a change in attitude to the sea itself. The sea-shore had formerly been regarded as a bleak and windswept place fit only for fishermen. Gradually it came to be regarded as having a beauty and a special atmosphere of its own. The change in mood can be traced in the work of a number of English writers and poets. There is, for instance, a passage in Jane Austen's *Persuasion* (first published in 1818) which reveals an attitude which would have been unthinkable fifty years earlier:

'Anne and Henrietta, finding themselves the earliest of the party the next morning, agreed to stroll down to the sea before breakfast – They went to the sands, to watch the flowing of the tide, which a fine south-easterly breeze was bringing in with all the grandeur which so flat a shore admitted. They praised the morning; gloried in the sea; sympathised in the delight of the fresh-feeling breeze – and were silent.'

The artists of the Romantic period reflected the same mood: the beach scenes of Constable, and David Cox; the estuaries and coastal views of Cotman and the other artists of the Norwich school; the picturesque harbours of Callcott and Stanfield; all these works marked a change in emphasis from the factual and documentary marine paintings of the eighteenth century. There was still a steady demand for ship portraits and men like Huggins and Samuel Walters were available to carry out such commissions with painstaking accuracy, but marine painting as a whole ceased to be the sole preserve of the specialist. As the following survey reveals, any artist felt at liberty to try his hand at a seascape or a beach scene. The result was that marine art in Britain was enriched and given an extraordinary variety which it had not possessed before.

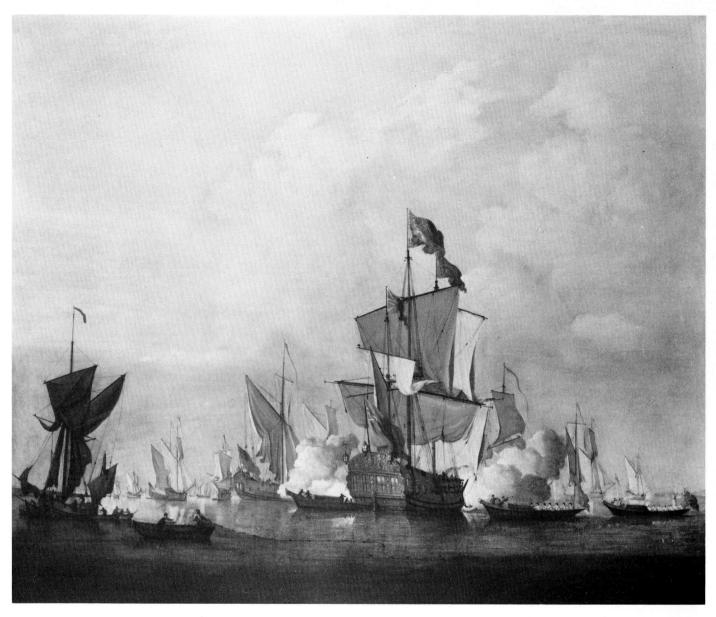

Peter Monamy c.1686-1749

15
A calm with a royal yacht firing a salute
Oil on canvas, 102·9 × 127 cm / 40½ × 50 in
Inscribed: P. Monamy Pinxt
Her Majesty Queen Elizabeth II

At one time attributed to van de Velde, this painting is now established as a fine example of Peter Monamy's work. Monamy was born in Jersey but came to England when he was young and became a house painter. The Register of the Company of Painter Stainers records that he was apprenticed on 3 September 1696. A further entry in the Company's records in 1726 orders that 'Mr Peter Monamy be admitted upon the Livery in consideration of his having presented the Company with a Valuable Seapiece of his own Painting'. He was described by Horace Walpole as 'a good painter of sea-pieces' and there are further references to him in Vertue's *Notebooks*, and J. T. Smith's *Nollekens and his Times*.

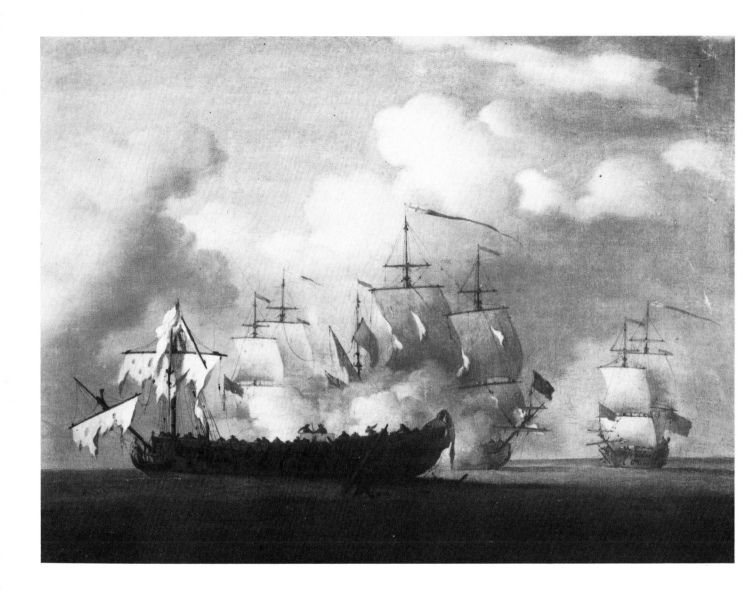

Monamy was at his best when portraying groups of ships at anchor and there are several pictures of this type in the collections of the National Maritime Museum at Greenwhich). This painting depicts a royal yacht firing a salute while a state barge pulls for the shore. The royal standard flying at the masthead of the yacht indicates the presence of the sovereign, and it seems likely that the scene represents the landing of King George II after one of his visits to Hanover.

16
The capture of the *Princessa*
Oil on canvas, 38·1 × 49·5 cm / 15 × 19½ in
Inscribed: P. Monamy
The National Maritime Museum, London

The *Princessa* was a Spanish ship of 70 guns. She was captured by three English ships, the *Kent*, the *Lenox*, and the *Orford* after a fierce action on 8 April 1740. She was brought into the service of the Royal Navy and eventually

finished her life as a hulk in Portsmouth harbour. It is interesting to compare this early example of a battle-piece by a British artist with later developments in the same field. In spite of the tattered sails and the smoke of the guns, the painting has a static and rather lifeless air about it. It is a far cry from Thomas Whitcombe's vigorous *Battle of Camperdown* (No.34) or the authentic realism of Pocock's *Defence at the Battle of the Glorious First of June* (No.27).

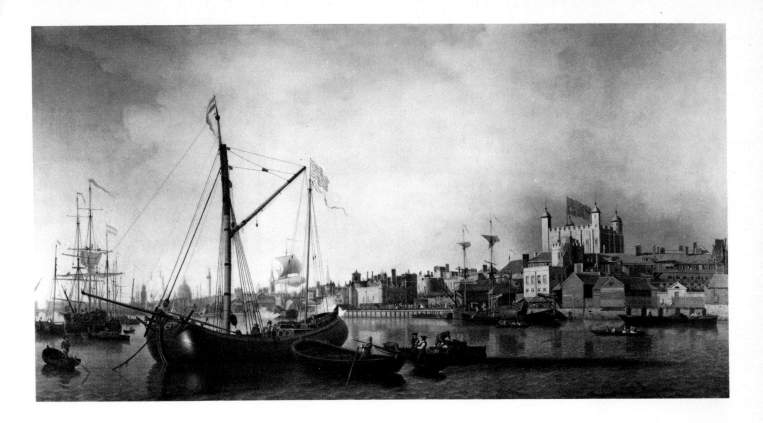

Samuel Scott 1701/2–1772

17
A view of the Tower of London
Oil on canvas
Inscribed: S. Scott 1753
Private collection
(*withdrawn from exhibition*)

Between the years 1746 and 1771 Samuel Scott painted at least eight pictures of the Tower of London seen from the south bank of the river. The view point is almost identical in each version, and the main differences lie in the grouping of the ships and small boats. This painting is generally considered to be the finest of all the known versions. Like all Scott's pictures it is packed with incident, and although Farington's *Diary* noted that 'He never was at sea, except once in a yacht', the shipping is carefully and accurately observed. The royal standard flying on the Tower has led to the tradition that the painting depicts the scene on the King's birthday: the guns firing salutes in the distance and the large crowd gathered on the bank below the Tower certainly suggest that some festive event is taking place.

Samuel Scott was one of the founders of the British school of marine painting. In his younger days he imitated the younger van de Velde, and the success of Canaletto's Thames views inspired Scott to try his hand at similar subjects. In spite of these foreign influences, his best work has a strongly English flavour. Research by art historians has revealed only fragments of Scott's life. It is known that he was a friend of Hogarth, and that he lived at Twickenham and later at Bath, but of his personality we know little beyond Farington's remark that, "Scott was a warm tempered man but good natured."

18
St Saviour's Dock, Bermondsey, with St Paul's and The Monument seen across the Thames
Watercolour, 28·6 × 44·4 cm / $11\frac{1}{4}$ × $17\frac{1}{2}$ in
The Museum of London
(*not reproduced*)

It is typical of Samuel Scott's approach to his subject matter that he should place St Paul's in the far distance of this picture and devote his attention to activities on the foreshore. He makes no attempt to create a grand vista in the manner of Canaletto, but carefully delineates the jumbled mass of warehouses, and the work boats and skiffs drawn up on the mud. There is another version of this watercolour in a private collection which is signed and dated, 'Sam. Scott. 1753'.

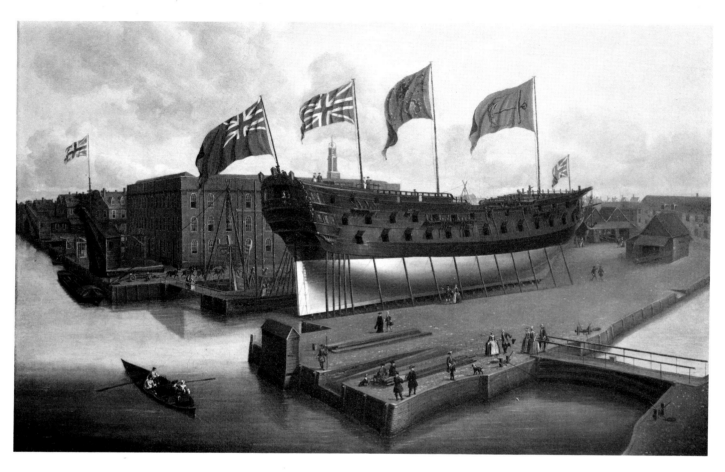

John Cleveley the Elder
c.1712–1777

19

HMS *Buckingham* on the stocks at Deptford
Oil on canvas, 81·2 × 121·2 cm/32 × 48 in
Inscribed: I. Cleveley pinxt, 1752
The National Maritime Museum, London
(*colour plate* II)

This colourful painting depicts a shipyard on the Thames at Deptford. On the stocks is a third-rate ship and the flags indicate that she is about to be launched. John Clevely was apprenticed as a shipwright, and for a time worked as a ship's carpenter. He lived at Kings Yard Row in Deptford with his wife and three sons, two of whom became marine artists of some distinction. He painted a number of shipyard scenes, many of them depicting launching ceremonies. All his pictures portray life and work on the Thames in fascinating detail. Although little known outside the circle of marine-painting connoisseurs and collectors his work deserves wider appreciation because it has more than documentary interest. His fresh, untutored vision, and his natural ability to create decorative patterns and bold shapes from the ships, the warehouses, the cranes and the piles of timber to be found along the water-front, make him a primitive painter of some stature.

Charles Brooking 1723–1759

When Oliver Warner wrote his *Introduction to British marine painting* in 1948, Charles Brooking was considered a minor marine artist from Deptford, of interest chiefly for his influence on Dominic Serres. During the space of thirty years, Brooking's reputation has soared and he is now generally regarded as the greatest English marine artist of the eighteenth century. Research has revealed 197 paintings which can be attributed to him, and it is known that in spite of his early death at the age of thirty-six he enjoyed a considerable reputation in his day. John Ellis referred to him as 'a celebrated Painter of Sea Pieces' in 1752, and Edward Dayes wrote of his painting, 'his colouring is light and clear, his water pellucid and transparent, with a firm, broad, spirited touch.

Had he lived, he would probably have been one of the finest marine painters that ever appeared in the world of arts.'

Brooking was brought up in Deptford and appears to have learnt the technical side of his art by assisting his father who was employed as a painter and decorator at Greenwich Hospital. A sea-piece inscribed 'C. Brooking, pinxit, aged 17 years' indicates that he had begun to specialise in marine painting at an early age. For some years he suffered at the hands of an unscrupulous picture dealer, but he was discovered by Taylor White, the Treasurer of the Foundling Hospital, who became his patron. He suffered from constant illness (probably tuberculosis) and when he died he left his wife and children in great poverty.

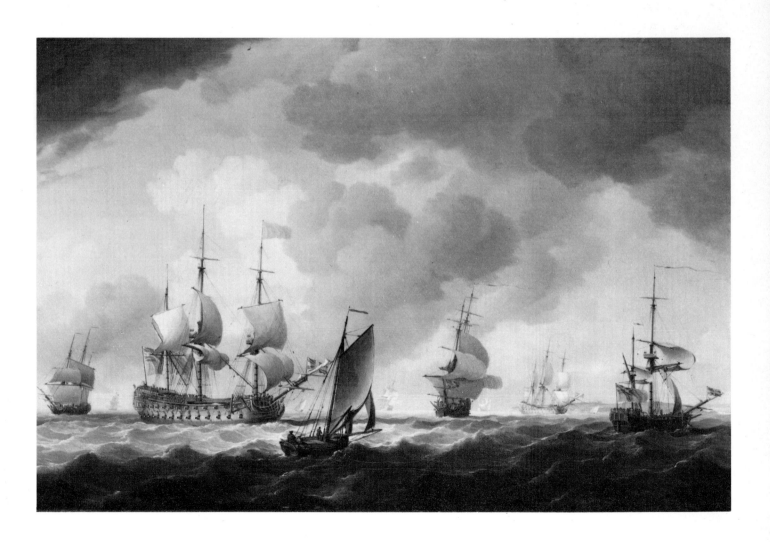

20 (on p.49)

A vice-admiral of the red and a fleet near a coast
Oil on canvas, 37 × 57 cm / 14½ × 22½ in
Inscribed: C. Brooking
The National Maritime Museum, London

The National Maritime Museum has a fine and varied collection of paintings by Brooking, but this must surely be the most beautiful of them all. The ships are drawn with consummate skill: every rope and halliard is accurately observed and the rounded hull forms appear wonderfully buoyant as they surge through the choppy seas. Even more impressive than this technical expertise is the manner in which Brooking has united the various elements into a harmonious composition. Broad shadows zig-zag across the water, leading the eye into the picture, and from one vessel to another. The billowing shapes of the sails are echoed in the billowing clouds, and the whole canvas, small as it is, has been filled with a soft light and a sense of atmosphere which anticipates by sixty or seventy years the achievements of Bonington and Constable. Brooking painted two other versions of this picture. One is in the Tate Gallery, and the other is a vast canvas some ten feet in length which is still to be seen in the Foundling Hospital for which it was commissioned in 1754.

21

A squadron going windward
Oil on canvas, 86·7 × 143·5 cm / 34⅛ × 56½ in
Inscribed: C. Brooking
Ferens Art Gallery, Kingston-upon-Hull

Like all other marine artists of the period, Brooking studied the work of van de Velde the Younger. This painting is of particular interest because it is copied directly from a painting by the Dutch artist entitled *A squadron going to windward in a gale*, which is now in the collections at Greenwich. Brooking has placed the four principal ships exactly as in van de Velde's composition, but has put his own stamp on the picture by altering the design of the ships to those of his own day, and by painting the sea and sky in his own manner. In fact Brooking himself was much imitated by later English artists. One of Pocock's sketchbooks at Greenwich includes several studies of pictures by Brooking, and Dominic Serres, who knew Brooking personally, modelled his style on that of the Deptford artist and frequently used similar compositional devices.

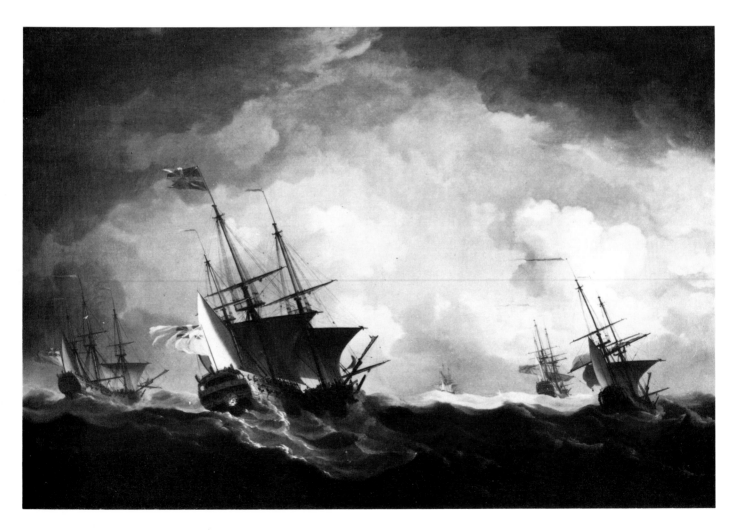

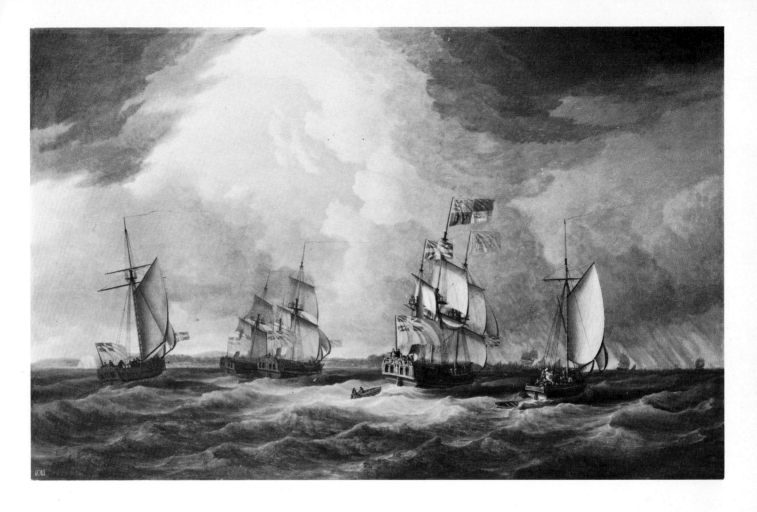

Dominic Serres 1722–1793

22

The Royal visit to the Fleet: George III, on board the *Augusta* yacht, returning to Spithead

Oil on canvas, 152·4 × 245·5 cm / 60 × 96½ in
Inscribed: D. Serres 1775
Her Majesty Queen Elizabeth II

This is one of a series of four paintings from Buckingham Palace which commemorate the visit of George III to the fleet in 1773. The King arrived at Portsmouth on 22 June, and went on board the *Barfleur* where he received a salute of 21 guns from the assembled ships. On 25 June he sailed across the Solent to Sandown in the yacht *Augusta*. In this painting the *Augusta*, flying the royal standard, is depicted on her return journey to Spithead. Culver Cliff, on the east coast of the Isle of Wight, is on the left of the picture. The King can be seen standing at the stern of the *Augusta*, and the other vessels can be explained by an entry in the Annual Register which noted that the King was accompanied by, 'a very great number of yachts and other sailing vessels and boats, many of them full of nobility and gentry'.

Dominic Serres was the official marine painter to George III, and so presumably this painting, and the other three in the series, were commissioned by the King. Unlike de Loutherbourg, Clarkson Stanfield, and several other marine painters who had the useful experience of painting stage scenery for some years, Serres was not so successful at painting on a grand scale. Nevertheless this very large picture is carried out with a certain vigour, and the sunlight on the water and the effects of the fresh south-easterly breeze are convincingly portrayed.

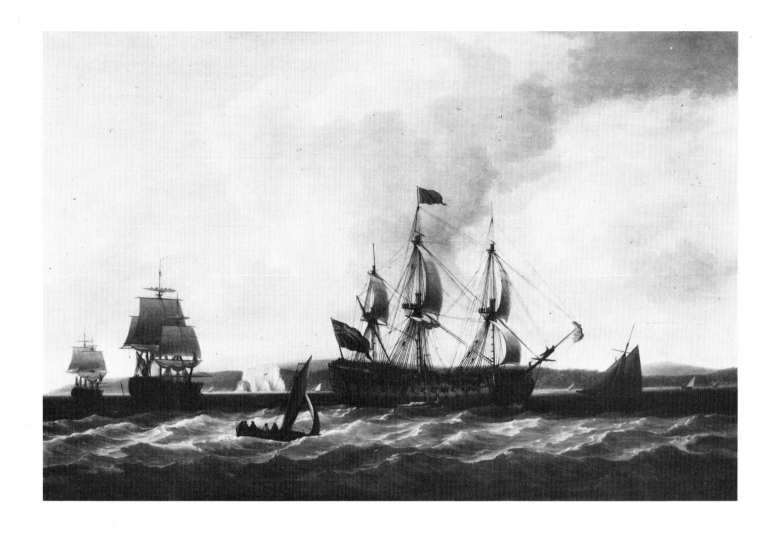

23
The *Royal George* of 1778
Oil on canvas, 90·2 × 133·4 cm / $35\frac{1}{2}$ × $52\frac{1}{2}$ in
Inscribed: D. Serres 1778
The National Maritime Museum, London

The *Royal George* was a first-rate ship of 100
guns. She was built at Woolwich in 1756 for the
phenomenal sum in those days of £54,664. She
was the flagship of Admiral Hawke at the Battle
of Quiberon Bay in 1759. This was one of the
most heroic actions ever fought by British ships:
the battle took place during a gale among
treacherous shoals and rocks off the French
coast. Unhappily this great ship is now
remembered chiefly for the ignoble
circumstances of her end. On 29 August 1782
she capsized and sank while at anchor at
Spithead with the loss of all hands. It was the
scandal of the age and the event was
commemorated in the familiar poem by William
Cowper which begins, 'Toll for the Brave!/The
brave that are no more!/All sunk beneath the
wave/Fast by their native shore.'

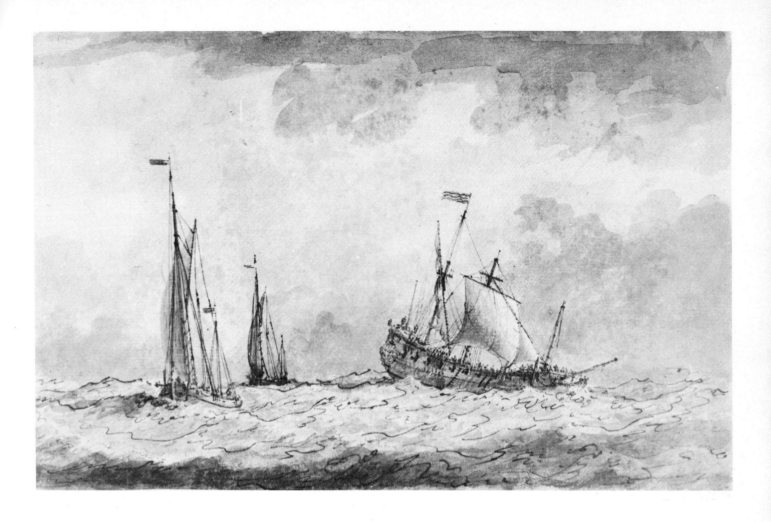

Charles Gore 1729–1806

24

A dismasted Dutch man-of-war under main course and staysail

Pen and grey wash, 18·4 × 28·7 cm / $7\frac{1}{4}$ × $11\frac{5}{16}$ in
The National Maritime Museum, London

This vigorous and freely drawn picture is typical of the work of Charles Gore, a gifted and under-rated amateur artist. His reputation has suffered because he copied a great number of van de Velde drawings and indeed has caused some confusion by drawing and painting on top of some of the original drawings. Gore came from a well-to-do family, was educated at Westminster School, and made himself independently wealthy by marrying a beautiful Yorkshire heiress. For some years he lived the life of a country gentleman at Horkstow Hall,

overlooking the river Humber. He and his family then moved to Southampton which was their home for the next sixteen years. During this period he went on cruises in his yacht every summer along the coasts of Normandy and Brittany. In later years he travelled extensively on the Continent, and in 1791 he settled permanently in Weimar where he numbered Goethe and Schiller among his close friends. There is a good account of his life in Oliver Warner's *Introduction to British marine painting*, and much useful information in an article by Peter Fraser, a copy of which is in the files of the Print Room at Greenwich.

25

A cutter and a lugger in a fresh breeze

Watercolour and bodycolour,
14·7 × 32·3 cm / $5\frac{13}{16}$ × $12\frac{3}{4}$ in
Inscribed (on the reverse): La canonade Walmy
parmi armees des allies Le Cap Gris-Nez avec
bateaux a voiles [*sic*]
The National Maritime Museum, London

Charles Gore's drawings of small sailing craft
have a freshness and a confident handling of
detail which must be due in part to his
enthusiasm for yachting. Ship design was one of
his hobbies, and it is known that he designed
and built his own yacht. The *Snail*, as she was
perversely named, was rigged as a cutter and
proved to be so swift that she had a considerable
influence on the design of the fast naval cutters
of the period. Gore made a habit of illustrating
his summer cruises, and the subject matter of
this lovely drawing (and the inscription on the
reverse) would suggest that this picture was
based on drawings made on board his yacht.

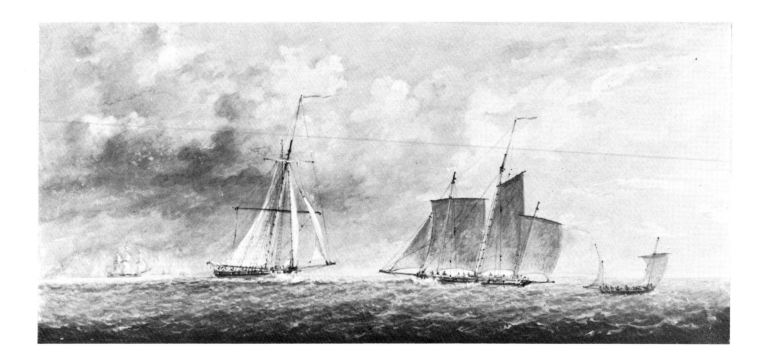

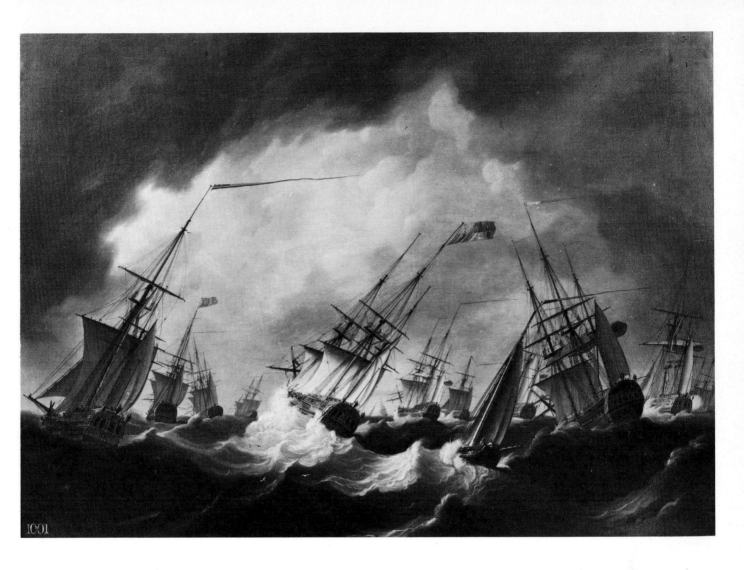

Richard Wright 1735–1775

26
Queen Charlotte's passage to England
Oil on canvas, 89·9 × 128·3 cm / $35\frac{3}{8} \times 50\frac{1}{2}$ in
Inscribed: R. Wright Pinx.
Her Majesty Queen Elizabeth II

On 23 August 1761 Princess Charlotte of
Mecklenburg-Strelitz, the future wife of George
III, went on board the royal yacht at Stade en
route for England. Five days later the yacht,
accompanied by a squadron under the command
of Admiral Lord Anson, put to sea. In the North
Sea they encountered a storm so severe that they
were nearly driven on to the Norwegian coast. It
was not till the 6 September that the squadron
reached Harwich and the poor Princess was able

to go ashore. The *Royal Charlotte* is shown in
the centre of the picture, buffeted by waves and
flying the royal standard at her masthead.

The painting is presumably the one which
Richard Wright exhibited at the Society of
Artists in 1762 with the title *A View of the Storm
when the queen was on her passage to England,
painted from a sketch drawn on board the Fubbes
yacht*. Although he was clearly an artist of some
talent, little is known about Richard Wright. He
was born in Liverpool, and exhibited twenty-six
pictures at the Society of Artists between 1762
and 1773, all of them marines. His most famous
picture was entitled *The Fishery*. It won him a
prize, and was subsequently engraved by
William Woollett.

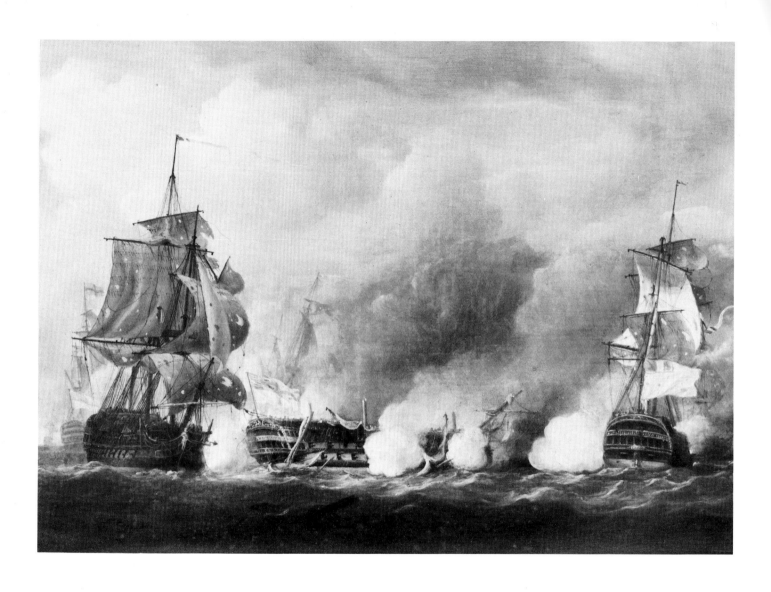

Nicholas Pocock 1740-1821

By no means the most gifted of English marine artists Nicholas Pocock has some claim to be considered the most interesting. The son of a Bristol seaman, he was apprenticed to his father in 1757. By the age of twenty-six he was master of a merchant ship and making one, sometimes two, voyages a year across the Atlantic to Charleston, South Carolina. He later voyaged to the West Indies, and made a stormy passage to the Mediterranean. Six of his logbooks have been preserved and each one is illustrated with meticulous pen-and-wash drawings of his ship and the many harbours which he visited. Pocock's twenty years' experience as a merchant seaman naturally stood him in good stead as a marine artist, but equally valuable was the opportunity he was given to witness a sea battle. An illustrated journal in the National Maritime Museum has revealed that Pocock was on board the frigate *Pegasus* with Lord Howe's fleet in 1794. He thus had a grandstand view of the Battle of the Glorious First of June, and was later able to depict the celebrated victories of the Nelson era with an authenticity which few other marine artists could hope to rival.

Although he was untaught and did not take up painting as a profession until he was in his early forties, Pocock became extremely successful. He moved from Bristol to a fine house in a fashionable part of Westminster and was soon besieged with commissions for paintings of naval engagements. Hundreds of his notes and sketches have survived, as well as some interesting correspondence with his patrons, and it is evident that he took unusual pains to gather information for each picture.

27
The Defence at the Battle of the Glorious First of June, 1794

Oil on canvas, 35·1 × 50·8 cm / 14 × 20 in
Inscribed: N. Pocock 1811
The National Maritime Museum, London

The Battle of the Glorious First of June took place in the Atlantic some four hundred miles westward of the French coast. It lasted four hours and like all sea battles of the period it was a noisy, bloody and confused affair. On one British ship thirty-six men were killed and sixty-seven wounded, and the French ship *Vengeur* heeled over and sank after a prolonged gun battle with the *Brunswick*. In Britain the First of June was hailed as a glorious victory. The French have always taken a different view as the grain convoy which the French fleet was protecting evaded capture and reached France safely. Pocock observed the battle from the deck of the frigate *Pegasus*, and kept an illustrated journal of the proceedings. His entry for 1st June opens characteristically with a seaman's observations on the weather: 'Wind remains about S by W. Moderate breeze and cloudy, a heavy swell from westward, at about 4 A.M. saw the enemy's fleet right abreast of us and distant about 7 miles right to leeward and all still on the larboard tack.'

He took note of the various flag signals flying at the mizzen-mast of the *Queen Charlotte*, and the damage caused to particular ships as the battle proceeded. In this painting he depicts a dismasted British ship under attack from two French ships. There is one reference in his Journal which is appropriate to the subject: 'The action continued very violent till near one o'clock and the ships dismasted seem'd to emerge from the smoke in such a manner that we could not see even who they had engaged last.'

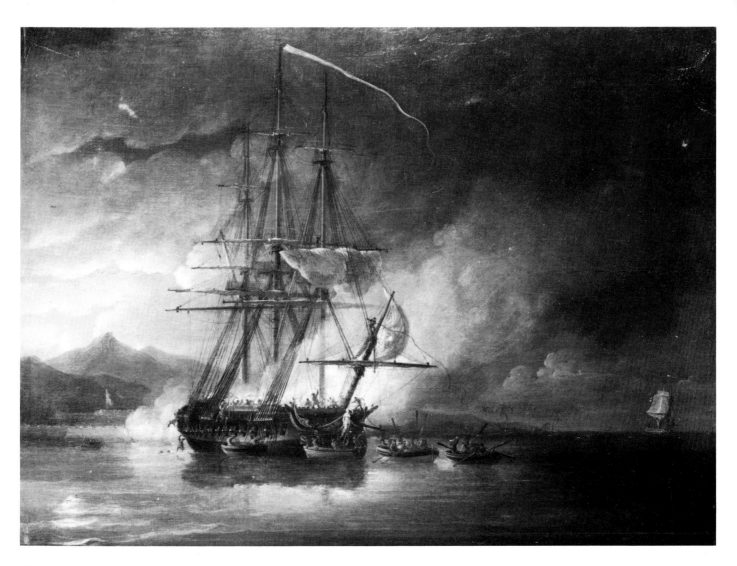

28
The cutting out of the *Hermione*,
24 October 1799
Oil on paper laid down on canvas,
48·3 × 64·5 cm / 19 × 25⅜ in
The National Maritime Museum, London

Pocock exhibited this picture at the Royal
Academy in 1800 with the title, *The capture of
the Hermione, Spanish frigate of 44 guns, 392
men, by Captain E. Hamilton of His Majesty's
ship Surprise of 24 guns*. Inspired by intense
patriotism and the fearless heroism of leaders
like Nelson, British seamen were constantly
engaging in incredible acts of bravery during the
latter part of the eighteenth century. This
painting illustrates a typical incident, when
Captain Hamilton decided to recapture the
Hermione, a former British frigate, while she lay
at anchor at Puerto Caballo. Relying on surprise
and showing an almost reckless initiative, a small
force of men from his ship crept alongside the
Spanish ship in the middle of the night,
overcame her crew and forced her to surrender.

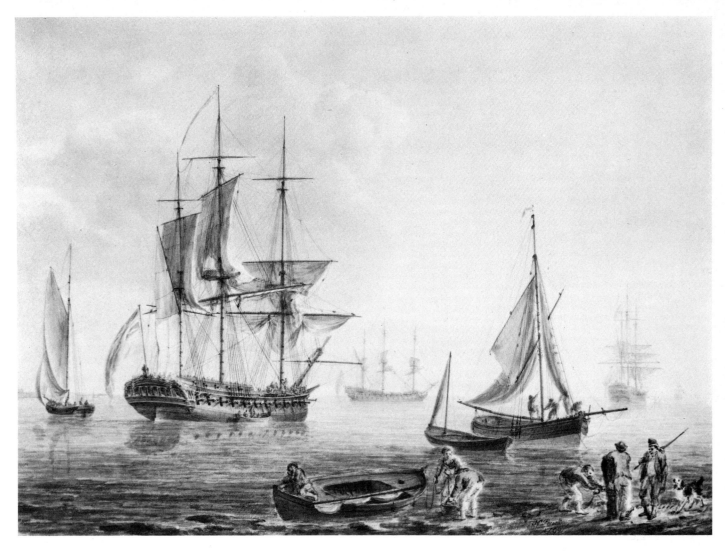

29
The red squadron in a calm
Watercolour, 43·2 × 57·2 cm / 17 × 22½ in
Inscribed: N. Pocock 1792
N. R. Omell Gallery, London
(*colour plate* III)

In February 1804, Pocock wrote a letter to
Richard Bright of Bristol, giving advice to his
daughter on how to set about painting in
watercolours. He suggested that she use only
three colours: yellow ochre, light red and indigo
blue, 'which are sufficient to produce any colour
or effect whatever'. He explained how to damp
the paper first, and how to use the light red and
blue for laying in the sky and the waves. 'The
misty clouds exhaling are produced by a large
brush dipp'd in the water (without colour) and
squeez'd between the finger and thumb. It will
in this dry state soften the edges of the Clouds
and vary the forms at pleasure ...' It is not
known where Pocock acquired his watercolour
technique, but his rather naïve drawing of the
seamen which he liked to introduce into his

foregrounds, would confirm the known facts
that he was largely self-taught. Although lacking
the skill and assurance of those later generations
of watercolourists which included Girtin,
Cotman and Bonington, his best work has a
charm of its own. This picture is a particularly
fine example of his mature style. The delicate
drawing of the ships and their rigging, and the
warm light enveloping the tranquil scene are
very characteristic.

30
The port of Tenby
Watercolour, 41·3 × 60·3 cm / $16\frac{1}{4}$ × $23\frac{3}{4}$ in
Inscribed: N. Pocock 1789
City Art Gallery, Bristol
(*not reproduced*)

In a letter to Pocock written in 1780 Sir Joshua
Reynolds advised the future marine artist to
emulate the practice of Claude Vernet which
was 'to paint from nature instead of drawing; to
carry your palette and pencils to the waterside'.
Pocock took the advice to heart, and went on
annual sketching expeditions in search of
suitable subjects. He visited the beaches and
harbours of the south coast, and spent much
time in Wales, especially in the area of the Menai
Straits, and along the southern shores of
Pembrokeshire and Carmarthen. Between 1805
and 1810 he showed six pictures of Tenby at the
exhibitions of the Old Water Colour Society.
The titles are all rather similar and it is not
possible to be sure which of them refers to this
particular picture.

31
A scene on board HMS *Deal Castle*
Watercolour, 18·8 × 15·4 cm / $7\frac{3}{8}$ × $6\frac{1}{16}$ in
Inscribed: T. Hearne 1804; (and on the reverse)
A Scene on board His Majesty's Ship Deal
Castle Captain J. Cumming in a Voyage from
the West Indies in the Year 1775.
The National Maritime Museum, London
(*colour plate* IV)

Although exterior views of men-of-war abound,
there are very few pictures in existence of life on
board ship in the eighteenth century. This
charming watercolour is given an added variety
by the fact that the artist was not a marine
painter, but an important member of the group
of early topographical artists who preceded
Girtin, Cotman, and De Wint. Thomas Hearne
was born near Malmesbury, came to London,
and won a premium given by the Society of
Artists. When Sir Ralph Payne was appointed
Governor of the Leeward Islands he invited
Hearne to accompany him on his voyage, and for
three and a half years the artist was in Payne's
employ. This watercolour is presumably based
on his observations and drawings made during
that period. The *Deal Castle* was a sixth-rate
ship of 24 guns, and Hearne's picture gives a
fascinating glimpse of the scene on her deck.
Note the awning which has been erected to
shield the helmsman from the tropical sun, and
the chicken coops in the foreground. Whether
the goat was a mascot, a supplier of milk, or was
destined to provide meat for the crew is a matter
for speculation.

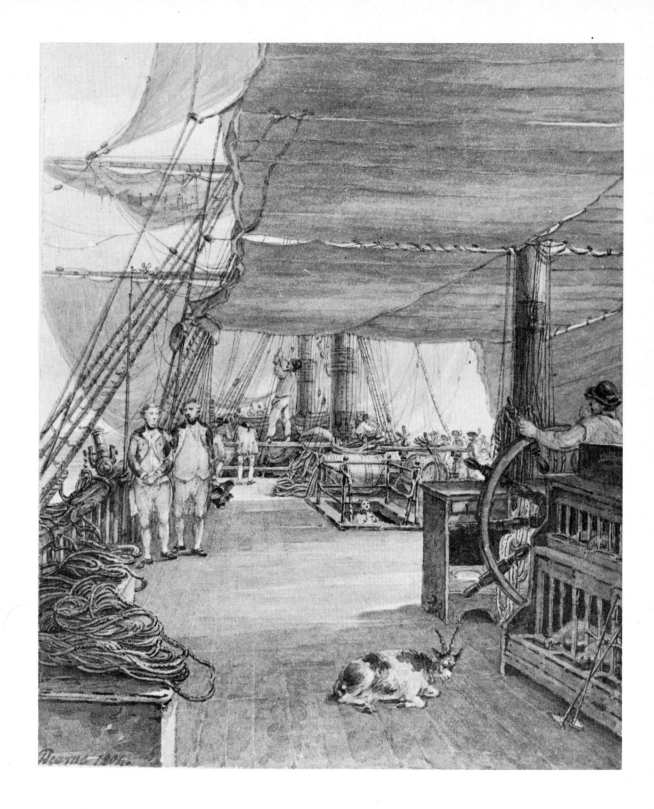

Pearne 1801

Robert Cleveley 1747–1809

32
**A *polacca* and men-of-war in light airs off
Stromboli, 1785**
Pen and grey wash, $15 \times 26 \cdot 2$ cm / $5\frac{15}{16} \times 10\frac{5}{16}$ in
Inscribed: R.C. 1785
The National Maritime Museum, London

Robert Cleveley and his twin brother John were
the sons of the marine artist John Cleveley the
Elder. They were both apprenticed in the
shipyards, John becoming a shipwright, and
Robert a caulker – a job which involved caulking
the seams between planks during the
construction of wooden ships. Robert Cleveley
later became well known for his paintings of sea
battles and was appointed marine painter to the
Prince of Wales. He outlived his twin brother by
more than twenty years, and died in a somewhat
dramatic manner by falling from the cliffs at
Dover. There is a very large collection of his
pen-and-wash drawings at Greenwich, of which
this is a typical example.

Thomas Whitcombe c.1752–1827

33
HMS *Undaunted* off Dover
Oil on canvas, 48·3 × 68·6 cm / 19 × 27 in
Inscribed: Thos. Whitcombe 1820
The National Maritime Museum, London

HMS *Undaunted* was a fifth-rate ship of 46 guns. She was built at Woolwich in 1807, took part in several actions in the Mediterranean in 1813, and was briefly in the public eye when she carried Napoleon to exile on the Isle of Elba in April 1814. Thomas Whitcombe, a London-born artist who exhibited fifty-six marine paintings at the Royal Academy, made a speciality of ship portraits. Although he naturally concentrated on portraying the ships in minute detail, he was also able to impart a lively and decorative quality to his commissions. He was particularly skilful at rendering waves and the effect of sunlight and shadow on the surface of the water.

34
**The Battle of Camperdown,
11 October 1797**
Oil on canvas, 121·9 × 182·9 cm / 48 × 72 in
The Tate Gallery, London

The Battle of Camperdown was fought about
three miles north-west of Camperdown
(Kamperduijn) on the Dutch coast. The British
fleet under Admiral Duncan were evenly
matched against the Dutch under Vice-Admiral
de Winter, each side bringing sixteen ships of
the line into battle. The Dutch fought with
obstinate courage but after four hours were
battered into surrender by the superior fire
power and accuracy of the British guns. The ten
Dutch ships which were captured were so
damaged that they never saw service again, and
two of them sank on the way to England.
Thomas Whitcombe's painting lacks the
theatrical power and drama of de
Loutherbourg's portrayal of the same battle
(also in the Tate Gallery), but is a more accurate
representation, and probably gives a very good
idea of how the ships must have looked to an
onlooker in the closing stages of the battle. On
the left is de Winter's flagship the *Vrijheid*. She
has lost her foremast and mizzen-mast, and her
mainmast is about to topple overboard. She is
still exchanging broadsides with the ship in the
centre of the picture which is Duncan's flagship
the *Venerable*. In the right foreground is the
Dutch ship *Hercules* of 64 guns. A fine engraving
of this painting was made by T. Hellyer.

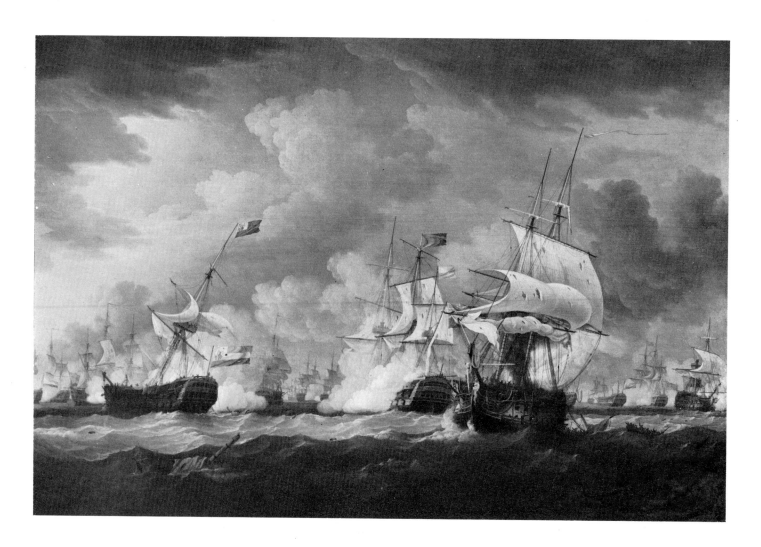

William Anderson 1757–1837

35
A collier brig at anchor in the Medway
Oil on panel, 27·9 × 41·9 cm / 11 × 16½ in
Inscribed: W. Anderson
Private collection

The river and estuary scenes of William Anderson have always been popular with collectors, and it is not hard to see why. He took as his model the brilliant 'tranquil marines' of van de Velde and replaced the Dutch boats and canals with everyday scenes on the Thames and Medway. Although his brushwork can be rather flat, and his treatment of waves and reflections somewhat rudimentary, there is an unpretentious, homely quality about his work which is very appealing. He exhibited nearly every year at the Royal Academy between 1787 and 1814 and earned a considerable reputation in his lifetime. Edward Dayes, in his *Professional Sketches*, which were published in 1805, was particularly lavish in his praise of Anderson: 'His style of colouring is clear and bright and his aerial perspective is well understood. The handling is clear, firm and decisive: but of his works, the smaller are by far the best: some of them are of the very first degree of eminence.'

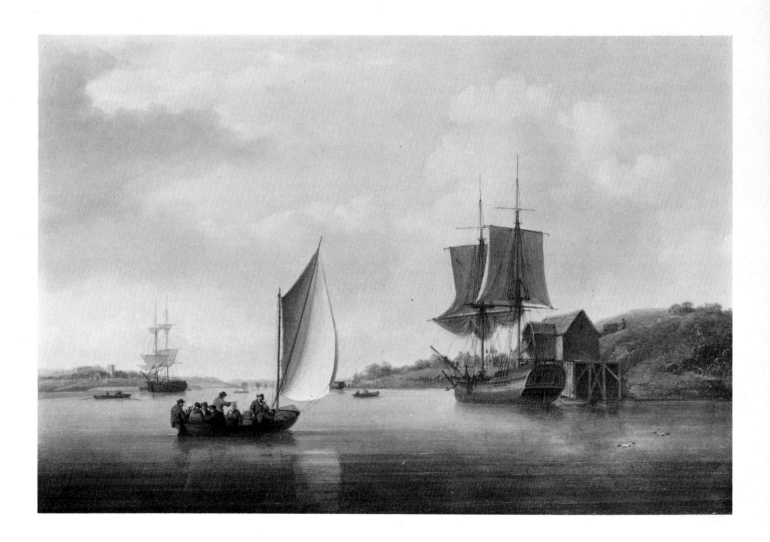

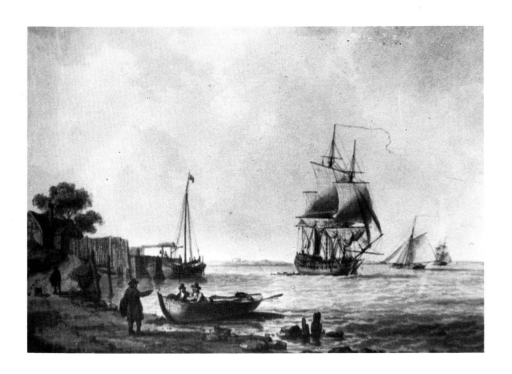

36
An estuary scene
Watercolour, 30 × 39·4 cm / 11¾ × 15½ in
Inscribed: W. Anderson 1790
Mr and Mrs F. B. Cockett

William Anderson was born in Scotland and was
a shipwright by trade. At some point in his early
life he came south to London and in 1787 he
exhibited for the first time at the Royal
Academy. In 1793 he was living at 44 Bell
Street, Lisson Green and later he moved to
2 Hamilton Terrace in St John's Wood. This
picture, which was formerly in the famous
Ingram Collection of marine pictures, is an
attractive example of his work in watercolours.
Although it is possible to trace the influence of
the Dutch masters in Anderson's oil paintings,
his watercolours, like those of his contemporary
Nicholas Pocock, are entirely English in spirit,
and are closely akin to the work of the
topographical draughtsmen such as Thomas
Hearne and Edward Dayes.

Thomas Luny 1759-1837

37
An armed cutter, a frigate and other shipping off a coast
Oil on canvas, 50·8 × 68·6 cm / 20 × 27 in
Inscribed: Luny
The National Maritime Museum, London

The paintings of Thomas Luny are very distinctive. Early on in his career he developed a method of painting short, lumpy seas and curling white wave crests which evidently pleased his many naval patrons, and which he adhered to in the majority of his pictures. Similar elements like the two-masted lugger in the foreground of this picture are often repeated, and his treatment of sails and rigging is also characteristic. His work varies in quality and much of his later work is very poor, due no doubt to the fact that he was severely crippled with rheumatoid arthritis. However, his drawing of ships was accomplished and his best pictures have a vigorous, painterly quality, and a fresh, sunny atmosphere. Luny served in the Royal Navy for a time, but illness forced him to retire to Devon, where he built up a thriving practice as a painter of ship portraits and naval engagements. He had a house built for him overlooking the harbour at Teignmouth, and is reputed to have left an estate of £14,000 to his niece.

38
The Pool of London
Oil on canvas, 41·6 × 63·1 cm / $16\frac{5}{8} × 25\frac{1}{4}$ in
Inscribed: Luny
The Museum of London
(*not reproduced*)

Thomas Luny was born in London, and
although he evidently spent much of his early
life at sea, it would appear that London
remained his home until he retired to Devon in
1810. In 1777 and 1778 he gave as his address
'Mr Holman's, St George's, Middlesex' when
he sent in pictures to the Society of Artists. This
would confirm the tradition that he was a pupil,
or anyway a friend, of Francis Holman whose
address at one time was Fawdon Fields, Old
Gravel Lane, St George's. In this painting Luny
depicts merchant shipping gathered in the Pool
of London, with London Bridge to the left, and
St Paul's beyond. The spires of St Magnus-the-
Martyr and St Mary-le-Bow can also be
glimpsed, as well as the Monument. Two other
versions of this picture are known: one, dated
1798, is in the collection of Mr and Mrs Paul
Mellon; and the other, dated 1803, is in the
collection of the Earl of Inchcape.

John Thomas Serres 1759–1825

Lieutenant Thomas Yates RN
c.1760–1796

39
A river scene with Peter boats
Watercolour, 21·1 × 32·8 cm / $8\frac{1}{4} × 12\frac{15}{16}$ in
Inscribed: J. T. Serres, 1790
The National Maritime Museum, London

Peter boats were small, clinker-built craft in
common use on the Thames during the
eighteenth and nineteenth centuries. They were
primarily used for fishing and were usually fitted
with a wet-well amidships to store the live fish.
They carried a simple spritsail rig which can be
clearly seen in this peaceful watercolour.
J. T. Serres was the eldest son of the marine
artist Dominic Serres. Although he succeeded
his father as marine painter to King George III,
and was for a time in the official employment of
the Admiralty, his life became dogged by
disasters. His wife was constantly unfaithful,
and her life of wild extravagance reduced Serres
to the point of bankruptcy. He died a few days
after being committed to prison for debt.

40
A view off the Lizard
Watercolour, 18·4 × 26 cm / $7\frac{1}{2} × 10\frac{1}{4}$ in
Inscribed: T. Yates 1790
Mr and Mrs F. B. Cockett

A number of professional seamen in the
eighteenth century became so proficient as
amateur marine artists that they were
encouraged to exhibit their pictures before a
larger public. Yates went so far as to exhibit his
pictures at the Royal Academy, and also
published a series of engravings of naval actions
which were based on his own drawings.
According to the records of the Shipwrights
Company he was apprenticed on 25 November
1774. He entered the Royal Navy and was
admitted to the rank of lieutenant in 1782. It is
usually recorded that he died as the result of a
duel, but this was not in fact the case. His wife
was an actress, said to be 'very elegant in her
person', and Yates got involved in a family
dispute over property which resulted in him
being shot as he was attempting to enter a house.
The shot proved fatal and in the words of the
Annual Register, 'Mr Yates made his will, and
expired about noon, leaving five children and a
widow pregnant with a sixth.'

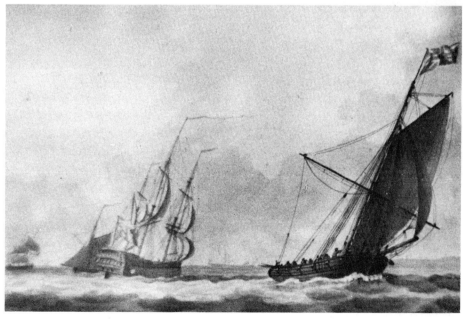

Samuel Drummond 1765–1844

41
The death of Nelson
Oil on canvas, 71·1 × 76·2 cm / 28 × 30 in
Norwich Castle Museum

The *Victory* had been in action an hour when
Nelson was shot. Captain Hardy, who had been
walking up and down the quarter-deck with the
admiral, turned to find Nelson on his knees, the
finger tips of his left hand touching the deck.
'They have done for me at last', Nelson said. 'I
hope not', said Hardy. 'Yes', was the reply, 'my
backbone is shot through'. Drummond's
painting depicts the scene a few minutes later

when Sergeant-Major Secker of the Marines,
assisted by two seamen, lifted the wounded
admiral to carry him down to the surgeon in the
cockpit. Nelson's left arm is on the shoulder of
the white-haired Captain Hardy. Immediately
behind Nelson, midshipman Pollard aims his
musket at the French marksman in the fighting
tops of the *Redoubtable* who fired the fatal shot.

Samuel Owen 1768–1857

42
River scene with shipping
Watercolour, 21·5 × 17·5 cm / 8½ × 7 in
Inscribed : S. Owen
Laing Art Gallery, Newcastle-upon-Tyne

Samuel Owen was a marine artist with an
attractive and most accomplished technique in
watercolours. Although he showed no great
originality in his style or choice of subject
matter, he is nevertheless an artist, like Charles
Gore, who deserves wider recognition. There
are some particularly good examples of his work
in the Victoria and Albert Museum and they
show that he was equally adept at painting
shipping in rough seas, and shipping at anchor.
Some of his watercolours were commissioned by
engravers, one of his best productions being a
series of drawings which were engraved by
W. B. Cooke for a book on the Thames.

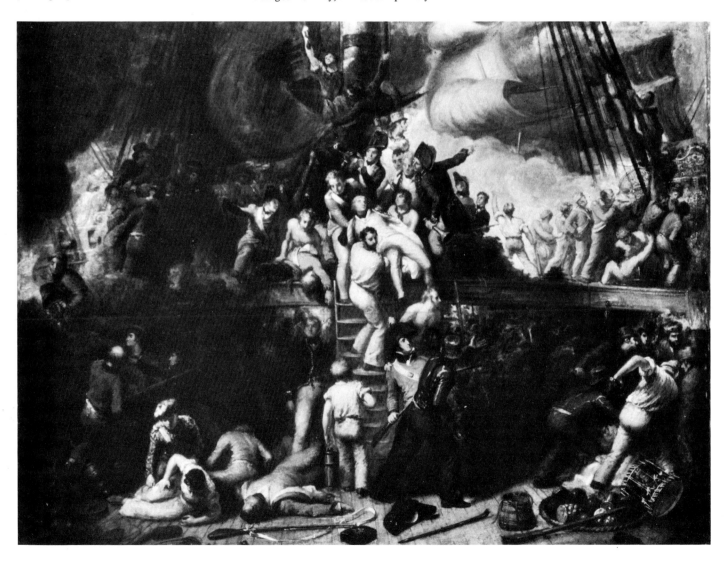

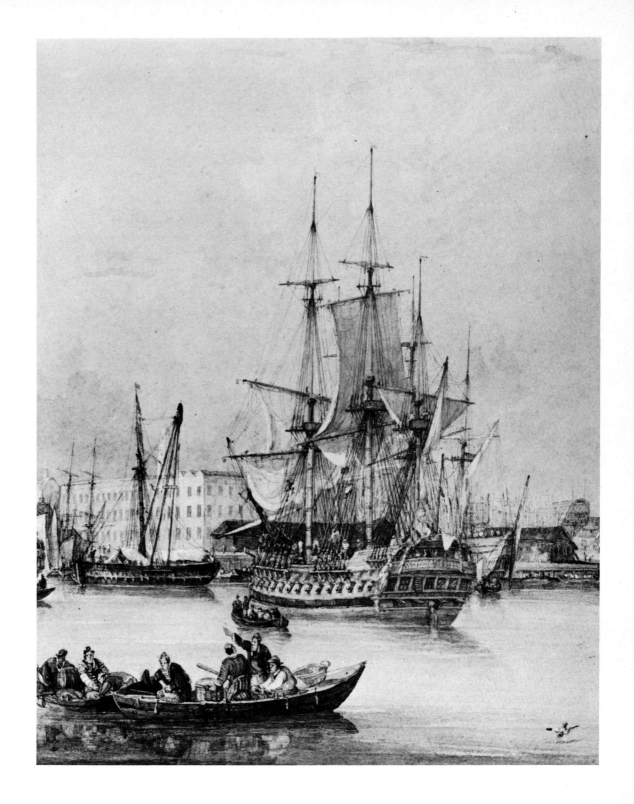

Francis Swaine fl.1761–1782

43
English yacht and fishing boat becalmed off the shore
Pen and grey wash, 18 × 22·7 cm / $7\frac{1}{16} \times 8\frac{15}{16}$ in
Inscribed: F. Swaine
The National Maritime Museum, London

The numerous drawings by Francis Swaine depicting shipping in river estuaries are clearly based on Dutch models, but nevertheless have a decidedly English air about them. Indeed his cloudy skies, and the sense of atmosphere which he sometimes introduced into his work, anticipates the later achievements of more distinguished watercolour artists. It is believed that Swaine was at one time a messenger in the Navy Office, and he lived for many years at Stretton Ground, Westminster. Some of his oil paintings are very fine and it is interesting to note that he was awarded the Society of Arts prize for sea-pieces in the years 1764 and 1765.

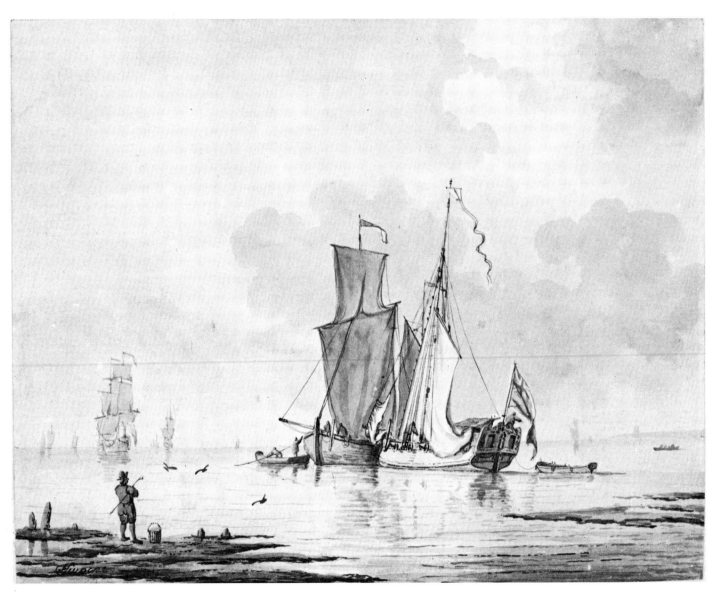

Francis Holman fl.1767–1790

44
A dockyard at Wapping
Oil on canvas, 78·8 × 127 cm / 31 × 50 in
The Tate Gallery, London

Francis Holman is one of several marine artists who have provided us with a comprehensive pictorial record of the ships and dockyards of the Georgian era, but of whose personal life we know almost nothing. It is believed that Holman was of Cornish origin, and there is a tradition that Thomas Luny was his pupil. He exhibited regularly at the Royal Academy between 1774 and 1784. This delightful painting shows us everyday life on the waterfront in the 1780s. A number of details in the picture have made it possible to pin-point the exact location, which is a private dockyard at Wapping. The building on the left inscribed 'MORLEY SAILMAKER' was owned by the firm of John Morley and Son which was established at 225 Wapping in 1783–4. In the centre of the picture the two

ships H MS *John* and H MS *William and Elizabeth* are shown in dry dock. The Lloyds Lists for the period 1770–90 include a *William and Elizabeth* which was built by Maitland and Co. on the Thames. Although Holman painted several dockyard scenes, it seems probable that this picture must be the one which he exhibited at the Royal Academy in 1784 under the title *A shipyard upon the Thames*.

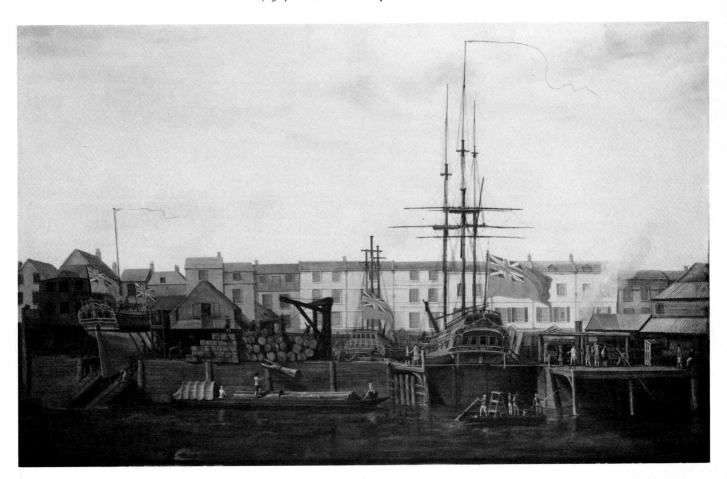

45
The *Fly* privateer
Oil on canvas, 25·4 × 36·8 cm / 10 × 14½ in
Inscribed: F. Holman 1779
The National Maritime Museum, London

Holman was particular adept at ship portraits, and although this is a rather modest example his work in this sphere, it has been included to show that marine artists did not only paint first-rate men-of-war or the massive ships of the East India Company. Many artists made a steady living by painting unpretentious pictures like this for naval officers and ship owners. Although they can scarcely be regarded as works of art they invariably have a colourful and decorative quality which has made them attractive to collectors. *Fly* seems to have been a very common name for small sailing craft in the eighteenth century, but Rupert Jones's list records a sloop of 16 guns, built in 1776, which is possibly the vessel shown here.

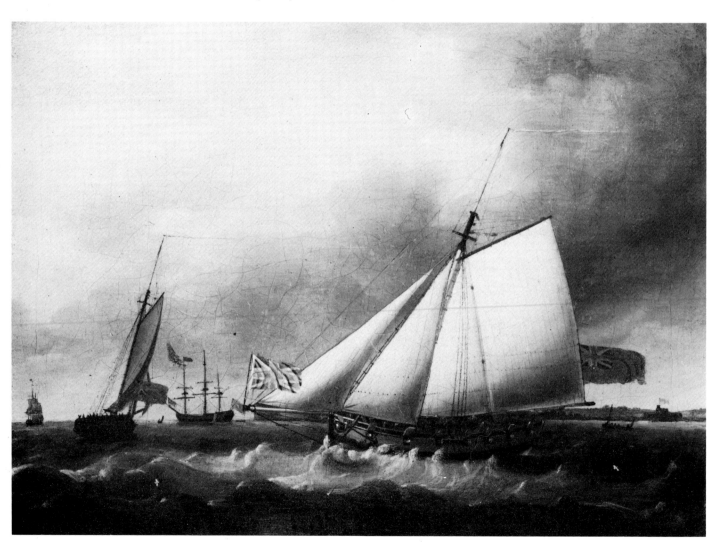

Samuel Atkins fl.1787–1808

46
In harbour
Watercolour, 35·5 × 48 cm / 14 × 19 in
Inscribed: Atkins Delt.
Laing Art Gallery, Newcastle-upon-Tyne

Samuel Atkins is a rather mysterious figure whose curiously primitive watercolours have become popular with collectors in recent years. The stiff drawing and slightly odd perspective apparent in this watercolour are typical of his harbour scenes. He seems to have taken a particular delight in portraying every detail of the standing and running rigging of anchored vessels, and for this reason his pictures have considerable documentary interest. The exact location of this subject is not known for certain, but the great number of ships visible in the distance, and a comparison with his other work would suggest that it is a scene on the Thames. Further examples of his work may be found in the collections of the Whitworth Art Gallery, the Victoria and Albert Museum and the National Maritime Museum.

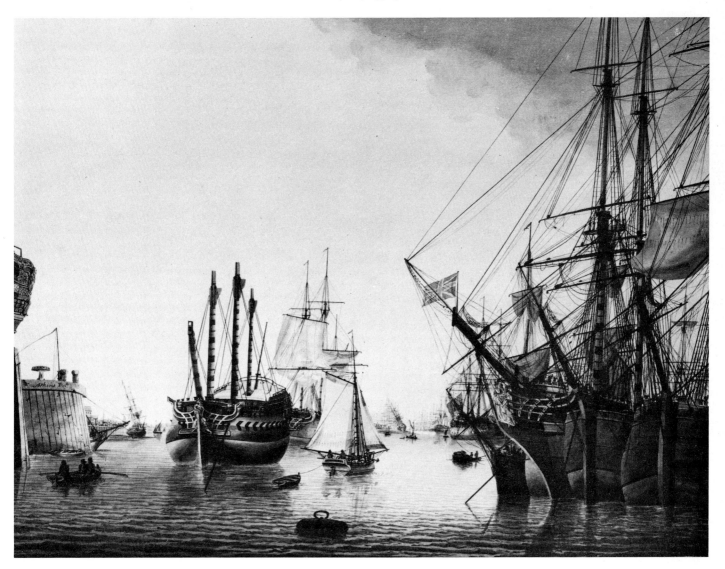

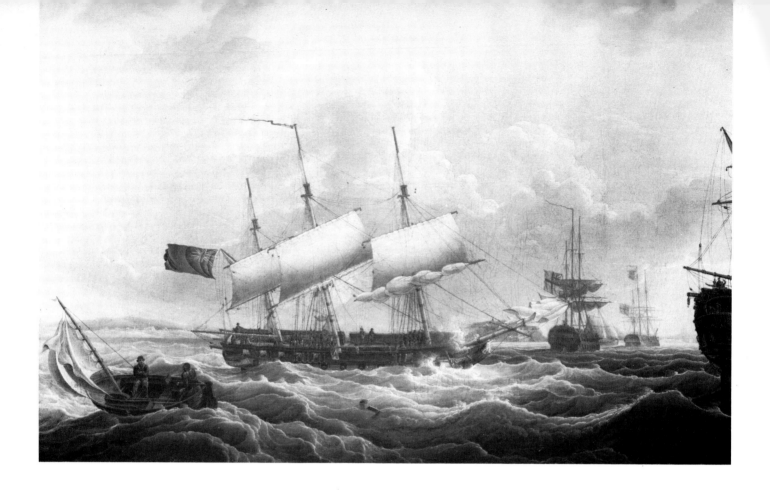

Robert Salmon 1775–1843(?)

47
Leaving port
Watercolour (oval shape), 22·8 × 33·1 cm /
9 × 13 in
Inscribed: Atkins
Whitworth Art Gallery, Manchester
(*not reproduced*)

The only facts known about the life of Samuel
Atkins are that he exhibited eighteen pictures at
the Royal Academy between 1787 and 1808, and
that in 1788 he issued the following
advertisement: 'MARINE DRAWING taught in
an easy, pleasing and expeditious manner by
S. Atkins No.78, Corner of Salisbury-street,
Strand, where specimens may be seen every day
(Sundays excepted) from ten till four during the
exhibition at the Royal Academy. N.B. Schools
attended'. It is said that he was at sea in the
1790s, and his meticulously accurate portrayal
of shipping would certainly suggest that he had
some sort of seafaring background. This picture
is one of a pair, the other being entitled *A calm*.

48
A frigate coming to anchor in the Mersey
Oil on canvas, 48·3 × 73·6 cm / 19 × 29 in
Inscribed: R.S. 1802
The National Maritime Museum, London
(*colour plate* V)

Robert Salmon emigrated to America in 1828
and set himself up in a studio at the end of
Marine Railway Wharf, overlooking Boston
Harbour. Much of his finest work was carried
out in Boston, and American art historians
usually consider him to have made an important
contribution to American art. He was, however,
born in Cumberland and spent his early life in
Liverpool and in Greenock. Many of his
curiously stylised ship portraits depict British
vessels, and there are good examples in the
collections at Greenwich and in the Walker Art
Gallery, Liverpool. His original technique and
personal vision give a distinction to his work
which raises it above the level of the more
traditional eighteenth-century marine artists.

J. M. W. Turner 1775-1851

To those who regard the Dutch as the only true masters of marine painting and who dismiss the English tradition of marine art as insignificant, it is only necessary to mention one name – Turner. In recent years his work has, perhaps, suffered from over-exposure. Exhibitions to commemorate the bicentenary of his birth, and a series of publications on his life and work, have established his international reputation beyond all doubt, but they have also had a noticeable tendency to cause all but the artist's most fervent admirers to retire exhausted and to turn away to less prolific and less overwhelming painters. Turner must, however, be numbered with van de Velde, Vernet, and Boudin as one of the greatest of all sea painters, and certainly the most important of all English marine artists – although the depiction of ships and the sea was, of course, only one aspect of his work.

The pictures below are a mere token of the contribution which he made to marine art.

Between the years 1801 and 1805 Turner took on the challenge of van de Velde the Younger and in one *tour de force* after another he proved that he was his equal. *Dutch boats in a gale* ('The Bridgewater sea-piece') was the first of the major sea-pieces, and it was followed by *Calais Pier*, *The shipwreck*, and other paintings in which he depicted stormy seas with an awe-inspiring power which no other artist has ever surpassed. The large *Dort* ('Dordrecht: the Dort packet boat from Rotterdam becalmed') of 1818 was his answer to the celebrated tranquil marines of the Dutch school, and in particular the work of Cuyp. Constable described this picture as 'the most complete work of genius I ever saw'. And during the 1830s Turner embarked on a third wave of sea-pieces, this time in an entirely personal style which broke away from all earlier traditions. Among these later works may be numbered *Staffa : Fingal's Cave*, the *Fighting Temeraire* of 1838 which

must be the most popular of his marine subjects today, and *Snowstorm : steam boat off a harbour's mouth*.

49 (on p. 77)
Waves breaking against the wind
Oil on canvas, 58·5 × 89 cm / 23 × 35 in
The Tate Gallery, London

Although smaller than Turner's usual format of 3 feet by 4 feet, this picture is typical of a large number of stormy seas painted by the artist during the 1830s, and is a companion to the equally beautiful *Waves breaking on a lee shore*. Some devotees of marine painting have a tendency to regard all Turner's later sea paintings with scepticism, and indeed it is worth remembering that some of his contemporaries

thought that he had taken leave of his senses. It must never be forgotten, however, that these impressions of sea and sky, apparently dashed off at furious speed, were the result of a lifetime of careful observations. Among the hundreds of his sketch-books in the British Museum are scores of studies of beach scenes, breaking waves, fishing boats and shipwrecks. They were almost all made on the spot. He braved all weathers, and on occasions put his life in some danger in order to gain first-hand experience of storm conditions. Added to this assiduous observation of the sea, was his remarkable visual memory which became something of a legend, and an original and inventive technique in oil painting and in watercolours which was the envy and despair of his contemporaries.

50 (opposite)
Sidmouth
Watercolour, 18·4 × 26·4 cm / $7\frac{1}{4}$ × $10\frac{3}{8}$ in
Whitworth Art Gallery, Manchester

Many of Turner's watercolours of marine
subjects were carried out with intention of being
engraved and published in book form. In 1816
W. B. Cooke published a volume entitled *The
Southern Coast* which included forty plates
based on Turner's watercolours. In 1826
Turner illustrated *Rivers of England* by
J. Bromley. This lively view of Sidmouth from
the sea was one of twelve watercolours prepared
for Thomas Lupton's *Ports of England* of 1828.
In fact only six of the engravings were
published, and the full set did not appear until
1856 when they were issued under a new title
The Harbours of England, with an accompanying
text by John Ruskin. Turner made a number of
coastal passages during his life, and one, which
was described by the Devon journalist Cyrus
Redding, is particularly appropriate to this
picture. The voyage was made in 1813 in a
Dutch boat owned by Captain Nichols. 'Turner
was invited to be of the party', he wrote. 'The
coast scenery was just to his taste. He was an
excellent sailor.' In a rising wind, with a heavy
swell running, they ran eastwards along the
Devon coast. Off Stoke's Point the sea rose
higher, but Turner was quite unaffected. 'When
we were on the crest of a wave, he now and then
articulated to himself – for we were sitting side-
by-side – "That's fine! – Fine!"'

51
The inner harbour, Dover
Pencil and wash, 19·8 × 26 cm / $7\frac{3}{4}$ × $10\frac{1}{4}$ in
The Royal Pavilion, Art Gallery and Museums,
Brighton

In the records of Brighton Museum this
drawing has always been attributed as an early
work of Turner (it was in the Godden Bequest,
and was formerly in the collection of
W. G. Rawlinson). It certainly bears the
hallmarks of the technique he employed in the
period between about 1791 and 1794. A
comparison with the *Interior of Tintern Abbey*
which was exhibited at the Royal Academy in
1794 shows the same crumbling line composed
of broken brush strokes, the same treatment of
clouds, and the similar use of simple washes for
the modelling of forms. We know from other
drawings that Turner visited Dover around
1793, and the characteristic interest in the
shipping, placed boldly in the foreground,
would seem to confirm the attribution. Turner
had entered the Royal Academy as a student on
11 December 1789 at the age of fourteen. He was
for a time a student of Thomas Malton, but by
1792 his style was most closely akin to that of
Edward Dayes, one of the topographical
draughtsmen whose watercolour technique
influenced many young artists of the period.

John Constable 1776–1837

52

Hove beach
Oil on paper laid on canvas,
$31 \cdot 7 \times 49 \cdot 5$ cm / $12\frac{1}{2} \times 19\frac{1}{2}$ in
Victoria and Albert Museum, London

Constable first visited Brighton in May 1824 for the sake of his wife's health: 'the warm weather has hurt her a good deal, and we are told we must try the sea', he wrote. His wife remained in Brighton until November of that year, and later returned for another six months in August 1825. Constable paid frequent visits to see her, and also visited the town again in 1826 and 1828. He disliked the noise and the fashionable airs of Brighton, and remarked that 'the beach is only Piccadilly or worse by the seaside'. However, he wasted no time but turned his attention to the sea and the waves breaking on the shingle. The oil sketches which he painted along the foreshore between the Chain Pier and Hove are often considered to be among the most original of all his works. We know from his letters to his friend Fisher that all these sketches were made on the spot, the smaller ones 'were done in the lid of my box on my knees as usual'. He captured the mood of this stretch of the coast with a directness and an intensity which has never been equalled. Indeed, it is hard to look at the sea in certain lights without being constantly reminded of his pictures.

53
Brighton Beach: early morning after a wet night
Pencil, pen and grey wash,
17·9 × 26 cm / $7\frac{1}{16}$ × $10\frac{1}{4}$ in
Inscribed (on reverse): Brighton Beach – early morning after a wet night
The Royal Pavilion, Art Gallery and Museums, Brighton

A view of Brighton beach looking east towards the old Chain Pier, which can be seen in the distance. In the foreground is one of the wooden capstans which were placed at intervals along the shore to enable the local fishermen to haul their boats up the steep shingle beach above the high-water mark. The boat on the left, and the larger of the two boats in the centre, are both clinker-built, two-masted luggers. They were a more conventional shape than the curious Brighton hogboats, and some of their direct descendants may still be found on the beach today. Like most of Constable's pen-and-wash drawings this was a sketchbook study never intended for exhibition, but as was his habit he noted the time of day and the weather conditions on the back of the drawing for future reference.

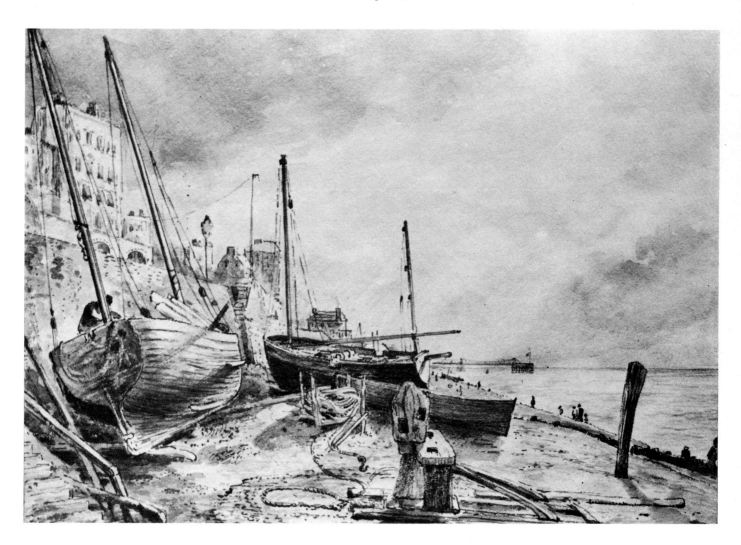

54
Shipping on the Orwell
Watercolour, $12 \cdot 7 \times 21 \cdot 6$ cm / $5 \times 8\frac{1}{2}$ in
Inscribed: On the Orwell
Mr and Mrs F. B. Cockett

Constable once expressed the view that pictures of boats were hackneyed and 'so little capable of the beautiful sentiment that belongs to landscapes that they have done a great deal of harm'. It is curious, therefore, that he should have drawn and painted marine subjects so often: among his most dazzling paintings are the three versions of *Yarmouth Jetty* and two pictures of Harwich lighthouse in which the sea and shipping play a major part; there are the beach scenes at Brighton and at Osmington, and the drawings he made at Folkestone harbour. This beautiful drawing is typical of many of his studies.

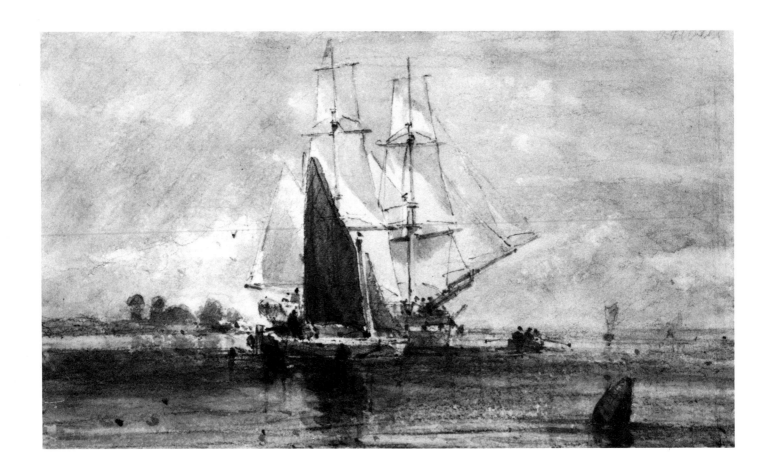

J. C. Schetky 1778–1874

55
Shipping becalmed off a port by moonlight
Pen and sepia wash,
$27 \cdot 5 \times 38 \cdot 7$ cm / $10\frac{13}{16} \times 15\frac{1}{4}$ in
Inscribed: J. C. Schetky – Marine Artist in
Ordinary to Her Majesty
The National Maritime Museum, London

Schetky's fondness for making drawings in
brown ink earned him the nickname 'Old Sepia'
from his pupils, so that it is appropriate that he
should be represented here by a work in that
particular medium. For twenty-five years
Schetky was professor of drawing at the Royal
Naval College in Portsmouth where he appears
to have been something of a character. He spent
much of his time making sketches from the small
boat that he owned. He was described by
Admiral Becher, a former pupil: 'A fine tall
fellow he was, with all the manners and
appearance of a sailor – always dressed in navy-
blue, and carried his *call*, and used to pipe us to
weigh anchor, and so on, like any boatswain in
the service.' As a marine artist, Schetky had a
distinguished career. He was marine painter to
the Duke of Clarence and King George IV, and
in 1844 was appointed 'Marine Artist in
Ordinary' to Queen Victoria. He exhibited
sixty-six pictures at the Royal Academy and was
frequently commissioned to paint
commemorative pictures of reviews of the fleet
and other royal occasions.

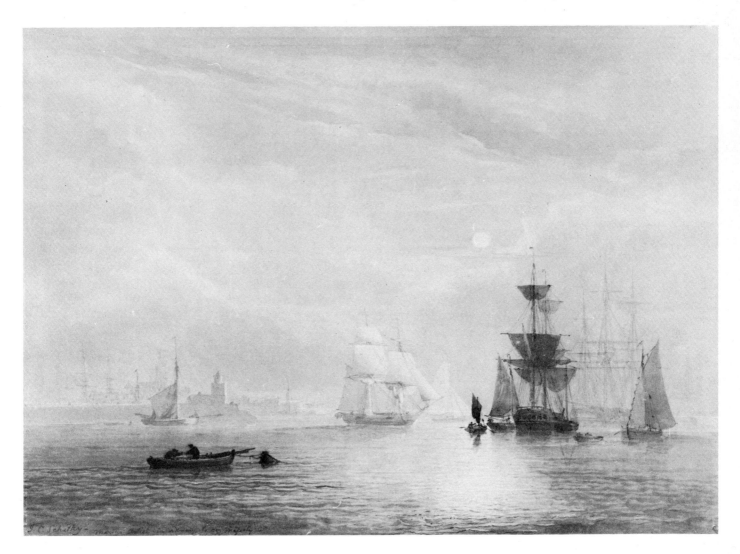

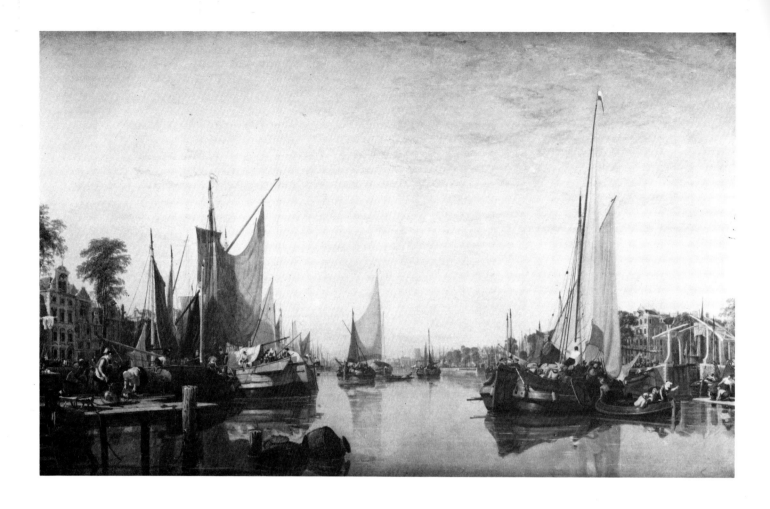

Augustus Wall Callcott 1779-1844

56
Rotterdam
Oil on canvas, 158·8 × 256·5 cm / 62½ × 101 in
Lord Howick of Glendale

Confronted with this impressive and highly
finished painting, it is not hard to see why
Callcott, who is little known today, should have
been held in such high regard in his lifetime. He
was knighted by Queen Victoria in 1837 and was
considered by some of his contemporaries to be
the equal of Turner, and superior to the earlier
Dutch masters. Of his *Entrance to the Pool of
London*, which was exhibited at the Royal
Academy in 1816, three years before *Rotterdam*,
Thomas Uwins remarked that it was 'quite as
fine as anything Cuyp ever painted, or anything

that has been done, in this way, in any age or
country'. It was the success of this painting
which no doubt encouraged Callcott to embark
on a second *tour de force*. He paid a visit to
Rotterdam in the autumn of 1818 and made
several preliminary drawings of shipping in the
harbour. Before embarking on the full-size
canvas, he made a small oil sketch of the subject,
which is now in a private collection. The final
work was exhibited at the Royal Academy in
1819, and Lord Grey, who had commissioned
the picture, paid Callcott 500 guineas for it. The
painting shows a variety of different types of
Dutch craft gathered along the banks of the
Leuvehaven, with the tower of St Laurence
church just visible in the far distance.

William John Huggins 1781–1845

57

The *Asia*, East Indiaman
Oil on canvas, 81·3 × 127 cm / 32 × 50 in
Inscribed: W. J. Huggins 1836
The National Maritime Museum, London

It has to be said that the innumerable ship portraits of W. J. Huggins all look very much alike. The ships are always viewed exactly broadside on and meticulous attention is paid to every detail of gear and rigging. The sun always gleams on the clean and curiously stylised curves of the sails and a fresh breeze whips up the surface of the blue-green waves. Ruskin remarked that Huggins gave 'no more idea of the look of a ship of the line going through the sea than might have been obtained by seeing one of the models floated in a fish-pond'. Nevertheless, Huggins pursued a most successful career as a marine artist. He was regularly employed by the East India Company to paint pictures of their ships, he exhibited regularly at the Royal Academy and the British Institution and he was appointed marine painter to William IV in 1834. While it would be foolish to regard his ship portraits as serious works of art, many of his paintings have a most decorative quality about them and one can imagine that the shipowners who commissioned them were well satisfied with the results. The *Asia*, depicted in this picture, was built in 1811 and is shown off Hong Kong towards the end of her career.

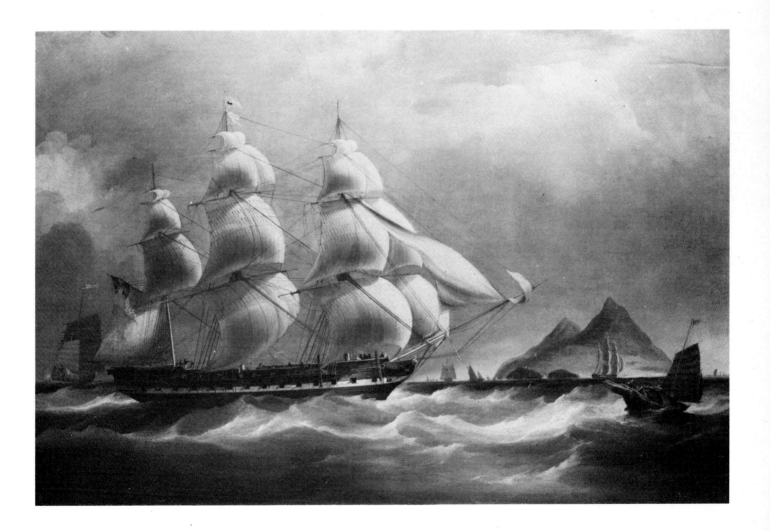

John Sell Cotman 1782–1842

58
Shipping at the mouth of the Thames
Watercolour, 40 × 54·6 cm / 15¾ × 21½ in
Inscribed: J. S. Cotman 1831
Victoria and Albert Museum, London

Cotman's genius as an artist found its truest expression in watercolours of landscape subjects, and in particular in a wonderful series of pictures which he made in the valley of the River Greta in Yorkshire between the years 1803 and 1805. But like so many Norwich artists, he observed the wherries and fishing boats on the numerous waterways of Norfolk and often made them the subject of his paintings and drawings.

Only four or five of his watercolours of marine subjects approach the quality and the originality of his Yorkshire subjects, but the *Dismasted brig* in the British Museum, and *The Needles* at Norwich must certainly be included among these. This highly finished picture of a Dutch *galliot*, with a man-of-war at anchor on the horizon, is less appealing to modern eyes than his earlier work, but it was far more acceptable to the public of his own day. The careful, and very accurate, depiction of the rigging and gear of the Dutch craft can be explained by the fact that Cotman was a keen amateur sailor, and the owner of a small sailing boat.

59
Fishing boats off Yarmouth
Oil on canvas, 63·5 × 76·2 cm / 25 × 30 in
Norwich Castle Museum

Cotman's oil paintings lack the freshness and
extraordinary refinement of his watercolours,
but the artist had a large family to keep, and in
the nineteenth century, as today, oil paintings
invariably commanded higher prices than
watercolours, and were also more acceptable for
public exhibitions. This is a fairly rare example
of a sea-piece in oils by Cotman. By any
standards it is very successful, and it is
interesting to compare it with the marines by
professional marine artists which are also shown
in this survey. The shapes formed by the clouds,
and the grouping of the boats are characteristic
of Cotman, but there is something about the
treatment of the sea, and the placing of the small
boat on the crest of a wave which is strongly
reminiscent of Turner. This is probably no
coincidence because every English artist who
attempted marine subjects from 1801 onwards
was aware of Turner's work. Moreover there are
in the British Museum some drawings by
Cotman which are copies of pictures by Turner
– one of these is a careful pencil study of *Dutch
boats in a gale*.

Joseph Walter 1783–1856

60

The *Great Western* off Portishead
Oil on canvas, 66 × 104·1 cm / 26 × 41 in
Inscribed: J. Walter
City Art Gallery, Bristol
(*not reproduced*)

Joseph Walter of Bristol was a local artist, and like John Ward of Hull and Samuel Walters of Liverpool, he devoted most of his time to painting the shipping in the harbour of his home town. Very little is known about his background as an artist, although a note on the back of one of his paintings at Bristol contains the interesting fragment of information that the picture is, 'by Walter 1842 a pupil of Luny The Great Marine Painter'. Between 1810 and 1837 Thomas Luny was living not so far away at Teignmouth so there is likely to be some truth in the statement, and, if so, it provides further evidence of the close links maintained between English marine artists. This colourful painting depicts the first of the three great steamships designed by Isambard Kingdom Brunel. The *Great Western* was built at Bristol and was 276 feet long, 35 feet broad and of 1,320 tons. In 1838 she crossed the Atlantic in fifteen days, breaking the record set up by the *Sirius*.

61

The *Britannia*, West Indiaman
Oil on canvas, 67·3 × 101·6 cm / 26½ × 40 in
Inscribed: J. Walter 1838
The National Maritime Museum, London
(*not reproduced*)

This is a particularly fine ship portrait by Joseph Walter showing the ship in three positions. The soft light and the cool grey colours are characteristic of his work, and show that a talented artist could, on occasions, produce a work of art from the exacting demands of the shipowners and shipmasters who commissioned such works. Joseph Walter built up a considerable reputation for himself in Bristol, and when he died the *Bristol Gazette* recorded that he was 'much respected, especially in the parish of St Augustine, with which he was connected from his early boyhood'.

David Cox 1783–1859

62
Calais Pier
Watercolour, 24·8 × 35·6 cm / 9¾ × 14 in
Inscribed : David Cox
Whitworth Art Gallery, Manchester

David Cox was first and foremost a landscape
painter, but his gift for portraying the effects of
wind and weather gave his coastal scenes a fresh
and breezy quality achieved by few other artists.
His vigorous watercolour technique was
particularly well-suited to the depiction of
scudding clouds and choppy seas. Cox made
three trips to the Continent. On the second trip
in 1829, he took the boat from Dover to Calais
and spent some time making sketches in and
around the French port. As with *Rhyl Sands*,
Cox painted several versions of *Calais Pier*.
There is a watercolour of the same subject at
Birmingham and a particularly fine oil painting
in the collections of the Walker Art Gallery,
Liverpool.

63
Rhyl Sands
Watercolour, 26·1 × 36·1 cm / 10$\frac{5}{16}$ × 14$\frac{1}{4}$ in
Inscribed: David Cox
Victoria and Albert Museum, London

'Abrupt and irregular lines are productive of a grand or stormy effect, whilst serenity is the result of even and horizontal lines', wrote David Cox in *The Young Artist's Companion*. *Rhyl Sands* is a splendid example of 'a stormy effect' and is one of the most exhilarating watercolours of a beach scene ever painted by an English artist. Cox was at Rhyl in the summer of 1854, and made a number of sketches on the beach. He painted two oil paintings of the same subject, one of which is in the Birmingham Art Gallery and depicts a windy day similar to this watercolour. The other, which is in the Manchester City Art Gallery, shows the sands on a sparkling, sunny day and is similar in mood to the brilliant beach scenes of Boudin.

90

64
Lancaster Sands: grey day
Watercolour, 25·5 × 36 cm / 10 × 14¼ in
Manchester City Art Gallery

Cox made a trip to Lancaster Sands in July 1834 and again in 1835. During the course of the next ten years he produced more than twenty watercolours depicting the local people with their horses and carts and dogs travelling to market across the sands from Kents Bank to Hest Bank. This watercolour has a freedom and a spontaneity missing from some of the more finished versions. The restricted palette of browns, pinks and greys, and the loose brush strokes make it particularly attractive.

Thomas Miles Richardson, Sr
1784–1848

65
Scene at Greenwich on 10th August 1822
Watercolour, 63·5 × 95·5 cm / 25 × 37¾ in
Inscribed: T. M. Richardson
Laing Art Gallery, Newcastle-upon-Tyne

This large and impressive watercolour was exhibited in 1826 at the Northumberland Institution for the Promotion of the Fine Arts with the title, *Scene at Greenwich, on the River Thames, on the morning of Saturday 10th August (1822), the Day on which His Most Gracious Majesty George IV embarked for Scotland.* The King's voyage to Scotland attracted the attention of a great number of marine artists. In a time of peace at sea, with few naval occasions

to depict, it provided a splendid opportunity to commemorate a nautical event of some interest to the nation. While most of the artists concentrated their attention on the *Royal George* which was the royal yacht in which the King travelled, Richardson has chosen to portray the crowds gathered to watch the embarkation scene. A hay barge is prominent among the anchored vessels on the right of the picture and the domes of the Royal Naval College gleam in the sunlight beyond. Among the boats on the left of the picture can be seen a skiff in which are several watermen in livery, with oars raised, which would suggest that the King or a member of his entourage may be among the fashionable crowd outside the tavern.

Peter de Wint 1784-1849

66
Barges on the Medway
Watercolour, 22·3 × 33·1 cm / 8¾ × 13 in
Inscribed (on the reverse): On the
Medway / P. de Wint
Manchester City Art Gallery

In his book on watercolour painting, which was
first published in 1944, Alfred Rich wrote: 'No
artist ever came nearer painting a perfect picture
than did Peter de Wint'. Such praise seems
extravagant until one is confronted by a picture
like this. Although his father was a doctor of
Dutch origin, Peter de Wint was born in
Staffordshire and his work is entirely in the
English tradition. He studied at the Royal
Academy Schools, was associated with Dr
Monro's famous circle of artists, and exhibited
regularly at the Royal Academy and the Water
Colour Society. Chiefly celebrated for his
cornfields and haymaking scenes, de Wint also
painted a number of canal and estuary scenes
with shipping, of which this is one of the most
memorable.

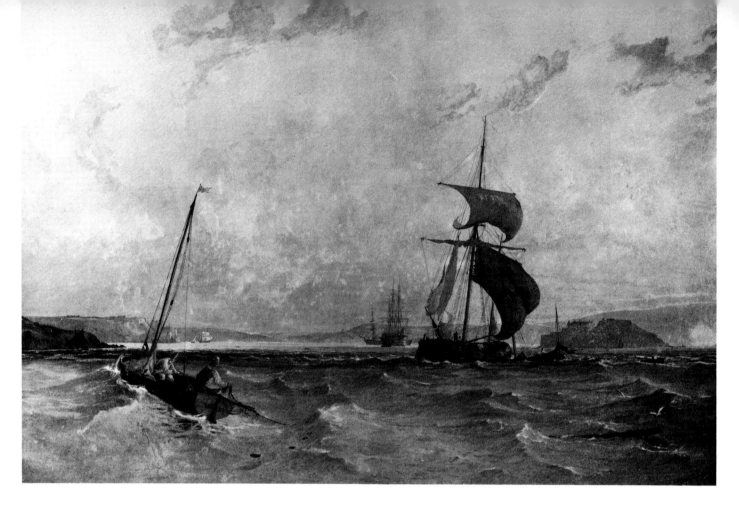

A. V. Copley Fielding 1787–1855

67
Bridlington Harbour
Watercolour, 46 × 62·2 cm / 18⅛ × 24½ in
Whitworth Art Gallery, Manchester
(*not reproduced*)

Although popular in his own day, Anthony
Vandyke Copley Fielding has since fallen into
disrepute, no doubt partly due to the large
numbers of his pictures which seem to be
painted from a formula. The titles, and
locations, may vary but it has to be said that
there is remarkably little difference between
Vessels in a storm off Folkestone in the
Manchester City Art Gallery, *Fishing smacks :
storm coming on* in the Lady Lever Art Gallery,
Boats entering Dover Harbour in the Whitworth
Art Gallery, and this view of Bridlington
harbour on the coast of Yorkshire. In each

picture will be found a fishing smack heeling
before the storm, her mainsail and jib starkly
illuminated against the lowering clouds; beyond
her a ship or a brig can be seen running for
shelter; to one side of the picture the wooden
piles of the harbour entrance can just be
glimpsed above the heaving waves; and in the
foreground there is in every case a wooden buoy,
a piece of floating driftwood, and a few seagulls.
Yet the formula is not unsuccessful, and it is
possible to go along some way with Ruskin's
extravagant eulogy in *Modern Painters*: 'No man
has ever given, with the same flashing freedom,
the race of a running tide under a stiff breeze;
nor caught, with the same grace and precision,
the curvature of the breaking wave, arrested or
accelerated by the wind.'

68
Plymouth Sound
Watercolour, 58·4 × 86·3 cm / 23 × 34 in
Inscribed : Copley Fielding 1826
Victoria and Albert Museum, London

Copley Fielding was the son of a portrait
painter, and his three brothers also became
artists. He came to London from the north of
England in 1809, and after a spell as a pupil of
John Varley, he set himself up as a painter of
landscape subjects, primarily in the medium of
watercolour. He exhibited at the Old Water
Colour Society and must have dominated the
annual exhibitions by the sheer number of his
pictures (no less than 327 in the space of seven
years). He moved to Sandgate in Kent in 1817
but spent much of the latter part of his life at
Brighton – he had a house at 41 Regency Square
and then at 2 Lansdowne Place. He travelled
widely throughout Britain painting coastal
views. This impressive watercolour is unusual
for Copley Fielding in that it depicts a relatively
tranquil scene, and substitutes a finely observed
sailing barge for the usual fishing smack.

William Collins 1788–1847

69
Shrimp boys at Cromer
Oil on canvas, 86·3 × 113·1 cm / 34 × 44½ in
Inscribed: W. Collins 1815
Guildhall Art Gallery, London

This is one of the most attractive of the numerous paintings by Collins which depict children on the sea shore. It was exhibited at the Royal Academy in 1816, and was the result of a visit to Norfolk the previous year. Another picture, entitled *Scene on the coast of Norfolk*, was bought by George IV, then Prince Regent, and is in the Royal Collection. William Collins was an extremely successful artist. He was born in London, was a student at the Royal Academy Schools, and first exhibited at the Royal Academy at the age of nineteen. While still in his early twenties he achieved fame with *The sale of the pet lamb*, and he numbered Sir Robert Peel, Sir George Beaumont, and Lord Liverpool among his patrons. By the 1840s he was living in a large house in Devonport Street, Hyde Park Gardens and had been appointed Librarian of the Royal Academy. Of a painting which he exhibited in 1846, John Ruskin wrote: 'I have never seen the oppression of sunlight in a clear, lurid, rainy atmosphere more perfectly or faithfully rendered.'

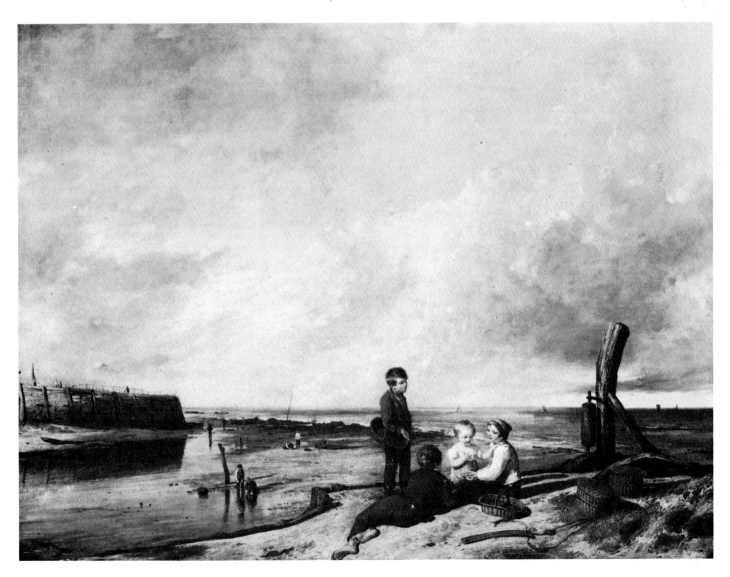

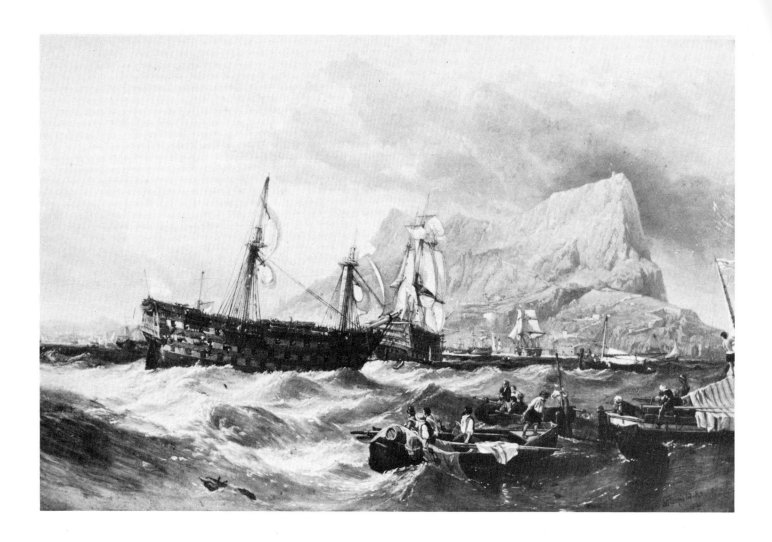

Clarkson Stanfield 1793–1867

Stanfield spent nine years of his early life as a
seaman. He went to sea in colliers at the age of
fifteen; he joined the Royal Navy at eighteen and
was fore-mast hand on the guardship *Namur* at
the Nore; and after being invalided out of the
Navy following a fall, he joined the merchant
service and travelled as far as China on board the
Warley. On his return he took a job as a scene-
painter at the East London Theatre opposite the
Tower of London, and for the next eighteen
years he earned his living painting scenery –
working for much of his time at the Drury Lane
Theatre. His scenery and dioramas proved
immensely popular: 'Only those who have seen

these really stupendous works can form an idea
of the inventive talent and artistic skill
displayed', was the opinion of a contemporary
writer, and indeed he is considered today to be
one of the most distinguished of all the English
scene-painters.

As an artist Stanfield is not easy to assess. His
unusually skilful technique as an oil painter, and
his natural ability to bring drama to a subject
make his finest work very impressive – most
impressive of all being his vast painting (some
fifteen feet in length) of the Battle of Trafalgar
hanging in the United Services Club which is far
superior to every other painting of that much
painted battle. John Ruskin was lavish in his
praise of Stanfield as a painter of seas and skies,

and even Constable conceded that 'he has great
power'. He was certainly the greatest marine
artist of his day, but his prolific output of
mediocre and sometimes over-pretty landscapes
and Italian coast scenery, tend somewhat to
diminish his achievement.

70
The *Victory* towed into Gibraltar
Oil on panel, 45·7 × 69·8 cm / 18 × 27½ in
Inscribed: C. Stanfield RA. 1854
Guildhall Art Gallery, London
(*colour plate* VI)

The day after the Battle of Trafalgar, the wind
rose to hurricane force and the resulting storm

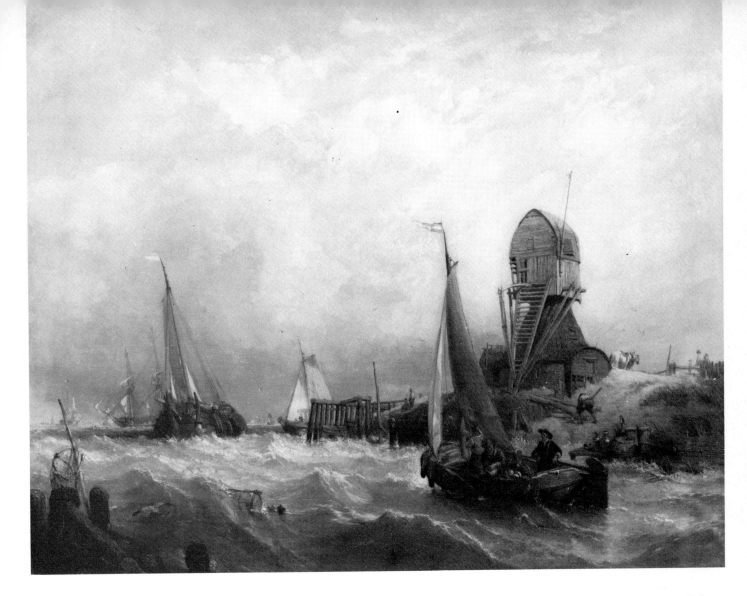

was considered by the sailors on board the ships to be far worse than the battle itself. The *Redoubtable* was overwhelmed by the waves, and several other French ships were driven on to the rocks near Cadiz and wrecked. Stanfield portrays the scene at Gibraltar on the evening of 28 October 1821, a week after the battle. A heavy sea is still running as the *Victory*, her wheel shot away, is towed into harbour by HMS *Neptune*. The flagship has lost her mizzen-mast and fore-topmast, and the damage to her hull can be clearly seen. Her flags are at half-mast in honour of Nelson whose body lies below, preserved in a cask of brandy. Stanfield draws on his background as a seaman and uses his technical gifts as a painter to produce a dramatic

and sparkling picture of great beauty. There is a small oil sketch of the same subject in the Victoria and Albert Museum, and a larger version in a private collection.

71
The entrance to the Zuyder Zee, Texel Island
Oil on canvas, 100·3 × 125·8 cm / 39½ × 49½ in
The Tate Gallery, London.

In common with Turner, Callcott, E. W. Cooke and other nineteenth-century landscape and marine artists, Stanfield made regular trips to the Continent, and was particularly impressed by the picturesque qualities of Holland. This

painting of Dutch boats in a fresh breeze is the type of subject at which he excelled. He was particularly adept at portraying the weather-beaten timbers of jetties and landing stages, and at conveying the movement and transparency of water. Ruskin observed that, 'he fears no difficulty, desires no assistance, takes his seas in open daylight, under general sunshine, and paints the element in its pure colour and complete forms'. This painting, which was exhibited at the Royal Academy in 1844, is similar in many respects to Stanfield's Diploma work of 1837, entitled *On the Scheldt, Holland*.

72
A quiet beach
Oil on canvas, 38 × 56·1 cm / 15 × 22⅛ in
Inscribed: C. Stanfield RA. 1854
Mr and Mrs David Cordingly

This may be the painting which Stanfield
exhibited at the Royal Academy in 1855 under
the title *Ilfracombe, North Devon*. It would
certainly seem to be somewhere on the coast of
Devon or Cornwall. Stanfield had visited the
West Country in order to make drawings for a
publication which came out in 1836, *Stanfield's
Coast Scenery*. This consisted of forty plates and
included views of Dartmouth, Plymouth and
Portsmouth. In 1842 he went on a holiday to

Cornwall with Charles Dickens, John Forster
and Daniel Maclise, and as a souvenir of the
occasion he painted a watercolour of his three
friends on top of Logan's Rock, and presented it
to Dickens. (The drawing is now among the
collection of Stanfield material in the Victoria
and Albert Museum.) Stanfield first met
Dickens in 1838. The writer's fascination for the
sea, and their mutual interest in the stage led to
their forming a life-long friendship. Stanfield
often helped with Dickens's amateur theatricals,
and much of their correspondence has been
preserved. A typical letter from Dickens begins:
'My Dear Stanny, I don't know whether you
understand our Hampstead engagement to hold
for today? Do you, you saline old Tarpaulin?'

Samuel Austin 1796–1834

73
Fishing boats off Eastbourne
Watercolour, 24·8 × 35·9 cm / 9¾ × 14⅛ in
Inscribed: S. Austin 1833
Victoria and Albert Museum, London
(*not reproduced*)

Samuel Austin was a skilful watercolour artist
who painted a variety of landscape subjects, but
whose reputation rests largely on his coastal
views – of which this is a very fine example. His
early life was spent in Liverpool. He was a pupil
at the Liverpool Bluecoat School from 1806 to
1809, and first exhibited at the Liverpool

Academy in 1822. He moved to London in 1824 and was a founder member of the Society of British Artists. As a young artist he received some instruction from Peter de Wint, and a number of his works also show the strong influence of Turner and Bonington.

John Ward 1798–1849

74
The return of the *William Lee*
Oil on canvas, 62 × 92 cm / 24½ × 36¼ in
Ferens Art Gallery, Kingston-upon-Hull

Every now and again a minor painter will produce a masterpiece. This is one such painting – the work of a local artist from Hull who devoted most of his life to depicting the shipping and docks of his native city. The majority of his paintings have a flat and rather lifeless air about them but *The return of the William Lee* is entirely different. Far more successfully than paintings by more sophisticated and talented artists, it captures the beauty and silent grandeur of the three-masted ship in the days of sail. It is, in fact, a commemorative picture and portrays the scene early on the morning of 22nd January 1839, when the *William Lee*

entered the mouth of the Humber Dock at Hull after her first voyage to Calcutta. The ship had formerly been a whaler but the decline of the whaling industry had prompted Thomas Thompson, her owner, to convert her to general cargo and send her to India. She was the first ship from Hull to trade with India and her successful return was an important occasion for the people of Hull. John Ward has recorded the scene with loving care: on the left of the picture a square-rigged Humber keel is moored alongside the wharf and to the right of the *William Lee* is the Baltic brig, *Consort*.

John Wilson Carmichael
1800–1868

75
The building of the *Great Eastern*
Watercolour and bodycolour,
21·7 × 32 cm / 8½ × 12 9/16 in
Inscribed: J W C 1857
The National Maritime Museum, London

Isambard Kingdom Brunel designed three
celebrated ships: the *Great Western* of 1838, the
Great Britain which was built at Bristol and
launched in 1843, and the largest ship of them
all, the *Great Eastern*. Carmichael painted two
watercolours of the ship in course of
construction at Millwall. This picture gives a
vivid impression of her size. She was 19,000 tons
gross, 680 feet long and 82 feet broad. Three

attempts were made to launch her and she finally
took to the water in November 1858. The cost of
building her ruined Brunel and the greatest
engineer of the age died before she sailed on her
maiden voyage. J. W. Carmichael was an
accomplished marine artist. He was born and
brought up in Newcastle and was the son of a
ship's carpenter. Although he painted a great
number of oil paintings of marine subjects, his
watercolours are generally more attractive,
being more fluent in style and less highly
finished. He published a book in 1859 entitled
The Art of Marine Painting in Watercolours, and
also supplied pictures for the *Illustrated London
News*.

R. P. Bonington 1802–1828

76
Coast scene in Picardy
Oil on canvas, 66·4 × 99 cm / 26⅛ × 39 in
Inscribed: R. P. Bonington
Ferens Art Gallery, Kingston-upon-Hull

Bonington comes second only to Turner in the influence which he had on the English marine painters of the nineteenth century. In a working career of little more than six years he perfected a dazzling technique in oil paint and watercolours which was the envy of older artists and the inspiration for younger ones. Clarkson Stanfield bought three lots at the sale of Bonington's work in 1829, and E. W. Cooke recorded in his diary a few months after he had taken his first lesson in oil painting, that he had been to see pictures by Bonington and found them 'truly splendid and surprising works of Art!! Nothing in Art so much affected me before.' Bonington had emigrated to France with the rest of his family in 1817. After a brief period of study at the Ecole

des Beaux-Arts, he set himself up in a studio at 27 rue Michel le Comte in Paris. For the next few years he went on regular sketching tours along the northern shores of France. The beaches of Normandy and Picardy provided him with a variety of subjects. This beautiful picture was painted around the year 1826 when Bonington was twenty-four years old. It is perhaps the most outstanding of all his coastal scenes. The sparkling colour, the brilliant intensity of the light, and the assurance of the drawing make it a remarkable work by any standard, but it is an astonishing achievement for so young a painter. His promising career was cut short by illness and he died on 23 September 1828, a month before his twenty-sixth birthday.

William Joy 1803–1867

77
Seascape with men-of-war
Watercolour, 25·8 × 36·5 cm / $10\frac{1}{8} \times 14\frac{3}{8}$ in
Inscribed: JOY, 1856
The National Maritime Museum, London

William Joy and his younger brother John Cantiloe Joy (1806–1866) frequently worked together on the same picture, and since they often left their work unsigned, or simply inscribed the word 'JOY', there has been some confusion about their relative merits. However, their watercolours are very distinctive, and the two pictures shown here are good examples of marine subjects by William Joy. The flickering white crests on the surface of the turquoise seas, and the crisp drawing of the ships are most characteristic of his work in this medium.

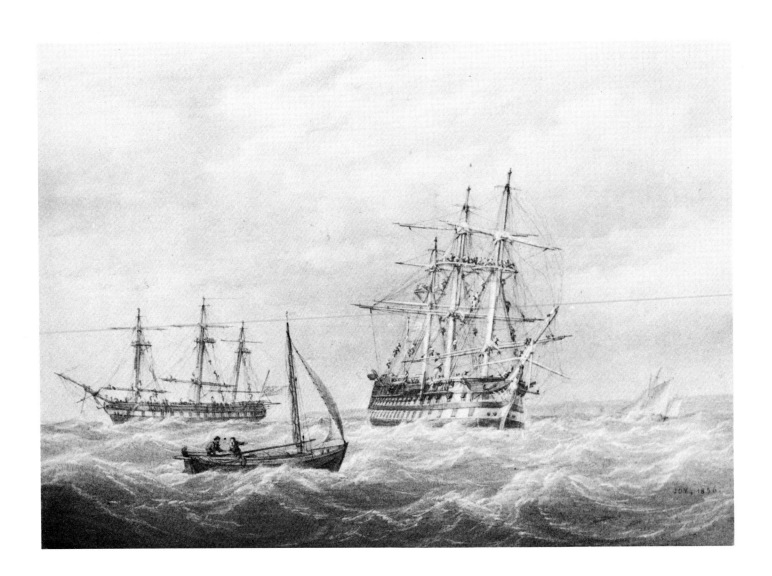

78
A lugger with other small craft in a fresh breeze
Watercolour, 20·1 × 30·4 cm / $7\frac{15}{16} \times 11\frac{15}{16}$ in
Inscribed: w. JOY 1859
The National Maritime Museum, London

The bold patterns of the lug-sails, and the fresh colours of this lively watercolour make it a particularly decorative work by William Joy. The three-masted vessel in the centre of the picture is one of the famous east-coast yawls. These were long, narrow, fine-lined boats, among the fastest of their kind in existence. They were launched from the beaches near Yarmouth and often carried a crew of up to forty men. The red-and-white flag at the masthead indicates that this is a pilot yawl. She would have been employed to take pilots and naval officers out to the fleet anchored in Yarmouth Roads. The brothers Joy were members of the Norwich school and used to exhibit at the Norwich Society of Artists.

Edward Duncan 1803–1882

79
Shipping off Whitby
Watercolour, 23·5 × 50·8 cm / $9\frac{1}{4}$ × 20 in
Inscribed: E. Duncan 1870
Mr and Mrs F. B. Cockett

Edward Duncan, who was born in Hampstead, started his working life as an aquatint engraver. He appears to have turned to marine subjects around 1826 after he had begun engraving the work of the marine painter, W. J. Huggins. He illustrated three titles in Vere Foster's series of practical painting books, the third of these being entitled *Advanced Studies in Marine Painting*. His painting varies in quality, but at its best, shows his considerable powers as a draughtsman. He was most at home in the medium of watercolours, of which this is a good example. On the right is a three-masted lugger heading for the entrance of Whitby harbour, and in the centre a collier brig heels under the stiff breeze.

Charles Bentley 1805/6–1854

80
East Cliff, Folkestone
Watercolour, 27·9 × 42·5 cm / 11 × 16¾ in
Inscribed: C. Bentley
Laing Art Gallery, Newcastle-upon-Tyne

In recent years the subject of this picture has been identified as the coast at Folkestone, with the entrance of the old harbour in the foreground, and the Martello Tower on the cliffs beyond. The vessel in the middle distance is a coal brig, which was one of the most common sights off the south coast in the nineteenth century. It is no accident that the seated figures on the right should be reminiscent of Bonington. Many English artists were influenced by his work, and Charles Bentley had more reason than most to fall under his spell. While apprenticed to Theodore Fielding, Bentley assisted him with the engravings for *Excursions sur les Côtes et dans les Ports de Normandie*. Many of the plates for this volume were taken from watercolours by Bonington.

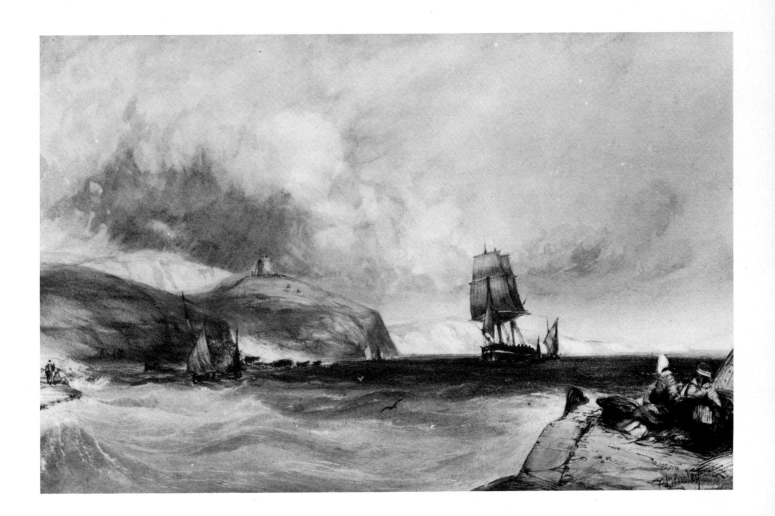

81
Coast scene with shipping
Watercolour, 34 × 50·2 cm / $13\frac{3}{8}$ × $19\frac{3}{4}$ in
Inscribed: C. Bentley 184(3)
Whitworth Art Gallery, Manchester

The deft use of a fine brush for details, combined with the freedom of execution and the lively sense of movement, make this a particularly impressive example of Charles Bentley's work. Nobody has yet succeeded in identifying the subject, although it is probably somewhere on the coast of France. Bentley went on a number of sketching tours along the French coast with his friend William Callow in the 1830s and 1840s. Unlike so many marine artists, Bentley did not have a seafaring background. He was born in Tottenham Court Road, where his father was a carpenter. He exhibited chiefly at the annual exhibitions of the Old Water Colour Society.

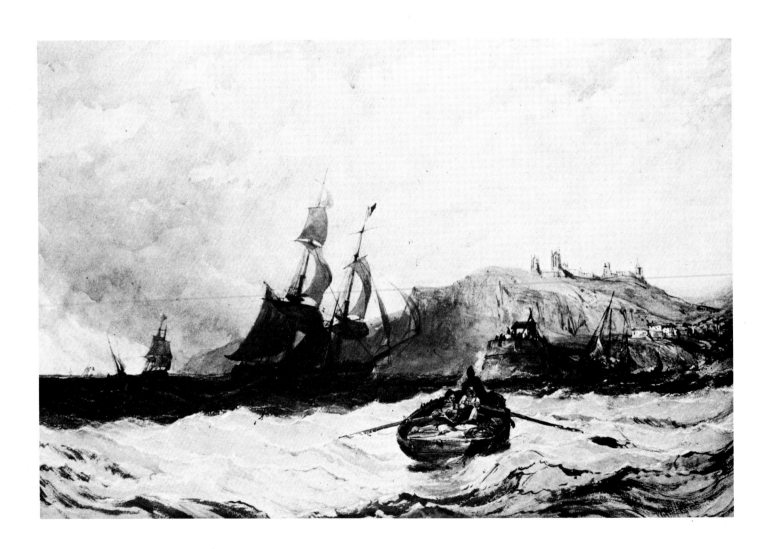

Captain R. B. Beechey RN
1808–1895

82

The Rescue
Oil on canvas, 91·4 × 137·1 cm / 36 × 54 in
Inscribed: R. Beechey 1875
Private collection

Captain Beechey drew on his years of experience as a professional seaman to depict ships and stormy seas with dramatic realism. This painting, which was exhibited at the Royal Academy in 1875, shows a lifeboat of the Royal National Lifeboat Institution rescuing the crew of a merchant ship which has struck the rocks off the Isle of Anglesey. The South Stack lighthouse, Holyhead, can be seen in the distance. Although usually referred to as Captain Beechey, this talented amateur artist reached the rank of full Admiral before he retired. He was one of the seven sons of the portrait painter Sir William Beechey. He was born in London, entered the Royal Navy in 1822 and was made a Captain in 1857. He was promoted to Rear Admiral in 1875, to Vice Admiral in 1879 and Admiral in 1885. A sketchbook of drawings which he made when midshipman on the *Blossom* in 1826, indicates that he was already taking himself seriously as an artist by the age of eighteen. No doubt he acquired his technical skill in the medium of oil paint from his father.

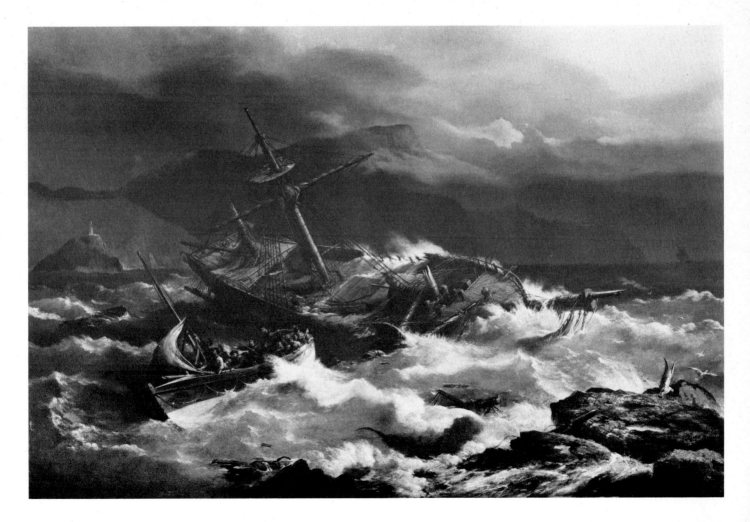

Miles Edmund Cotman 1810–1858

83
Boats on the Medway
Oil on canvas, 55·3 × 50·2 cm / 21¾ × 19¾ in
Norwich Castle Museum

In this small masterpiece Miles Edmund
Cotman, the eldest and most talented of the sons
of John Sell Cotman, has successfully combined
a subject taken from the repertoire of the Dutch
seventeenth-century masters, with the bold
pattern-making of his father's work. Although
the two boats in the picture are Dutch, they
would certainly be based on first-hand
observation. The Cotman family owned a small
boat called the *Jessie* in which they not only
explored the waterways of Norfolk, but also
made a number of coastal passages. On at least
two occasions (in 1828 and 1831) Miles Edmund
and his father sailed round the coast of East
Anglia to the Thames Estuary, and they spent
some weeks drawing and painting in the area of
the Medway.

84
Marine view
Watercolour, 23 × 32·7 cm / 9 1/16 × 12⅞ in
Norwich Castle Museum

The vessel on the right of this breezy picture is a
three-masted Yarmouth lugger. She is clinker-
built, has a lute stern, and in addition to her
three lug-sails, has a jib set on a short bow-sprit.
Every important detail of her hull form and rig
are depicted with an effortless accuracy which
can be explained by the artist's intimate
knowledge of sailing craft. There is an entry in
the diary of the future marine artist E. W. Cooke
which describes how he and the young Cotman
took a sailing boat down the river to Thorpe in
October 1828, 'wind blowing very hard, two
hours and a half coming back as we had to beat
all the way, got home at 9'. When he was not
teaching Norwich pupils, or assisting his father
with his drawing class at King's College,
London, Miles Edmund Cotman was out
making drawings of shipping.

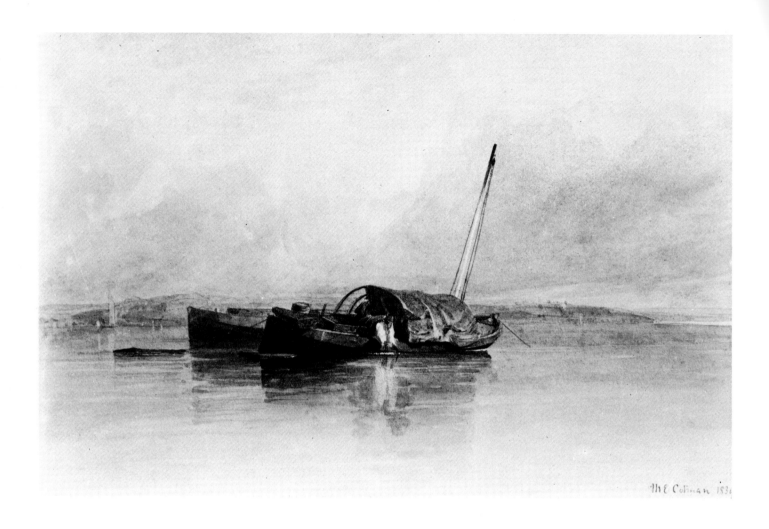

85
River scene
Watercolour, 15 × 23·8 cm / $5\frac{7}{8}$ × $9\frac{3}{8}$ in
Inscribed: M. E. Cotman 1839
Norwich Castle Museum

This typical scene on one of the waterways of Norfolk (probably Breydon Water) is painted with a masterly restraint, and a technique which, though apparently simple and effortless, is in fact extremely skilful. M. E. Cotman originally learnt from his father, and much of their work is almost indistinguishable, but he also absorbed the technical devices employed by later artists such as Bonington and Muller. To a much greater extent than his father, Miles Edmund concentrated on marine subjects. Thirty-five of the eighty-two pictures he exhibited at Norwich and almost all his exhibits at the British Institution and the Society of British Artists were marines – mostly of shipping on the Medway and the area along the coast and up the river near Great Yarmouth.

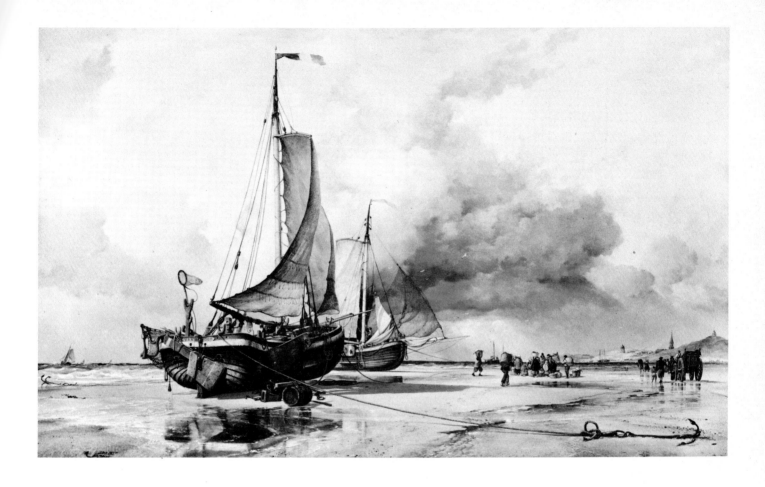

E. W. Cooke 1811–1880

Edward William Cooke was a typical product of the Victorian age. He was painstaking, industrious, and a man of many interests. He was an amateur archaeologist, a talented botanist and gardener, and an intrepid traveller. He also kept a regular diary from the age of seventeen. It provides an invaluable insight into his life and is also a source of information about many of the distinguished artists of the day. As a young man, Cooke was introduced to a wide circle of painters through the contacts of his father George, and his uncle W. B. Cooke, both of whom worked as engravers, and who numbered among their clients such men as Cotman, Prout, Callcott, Stanfield and Turner. Later in life Cooke assisted with the arrangement of exhibits for the Great Exhibition, and commissioned Norman Shaw to design a house for him at

Groombridge in Kent where he spent much of his time planning and supervising the gardens. By the time of his death in 1880 he had achieved the unusual distinction of being elected a Fellow of the Royal Society, as well as being a Royal Academician, and a Fellow of the Zoological Society, the Lepidoptera Society, and a Fellow of the Society of Arts.

86
Dutch pinks, Scheveningen
Oil on canvas, 67·3 × 108 cm / 26½ × 42½ in
Inscribed: VAN KOOK (on stern of vessel)
Guildhall Art Gallery, London

Cooke paid no less than sixteen visits to Holland, and spent most of his time drawing and painting the numerous different types of Dutch fishing boat. The long stretch of sandy beach at Scheveningen was one of his favourite haunts,

and he studied the activities of the fishermen in all weathers. The pinks in the foreground of this picture appear in several of his pictures – notably in his Diploma work for the Royal Academy, *Scheveling pinks running to anchor off Yarmouth*. On the stern of the nearest boat, he has inscribed VAN KOOK, which is his version of his name in Dutch, and may be taken as a tribute to the inspiration he received from Holland and the early Dutch marine painters. Five years after this picture was painted he presented a cheque to the Royal National Lifeboat Institution for the purchase of a new lifeboat, which was similarly named VAN KOOK.

87
**A Dutch *beurtman* aground on the
Terschelling Sands: in the North Sea after
a summer storm**
Oil on canvas, 106·8 × 167·6 cm / 42 × 66in
Inscribed: VAN KOOK
The Royal Holloway College, Egham

This is a splendid example of E. W. Cooke at his
most impressive. It is clearly based on his first-
hand observation of Dutch boats in heavy
weather and reveals a thorough understanding
of seamanship. The *beurtman* is shown a few
moments after running aground. The crew have
let go the heel of the sprit (which is the spar
shown horizontal in the picture) in order to spill
wind from the mainsail; over the bows several
men are heaving with boat hooks and oars in an
effort to push the boat clear of the sands. In the
stern a man grasps an anchor with the intention
of hurling it astern in order to prevent the boat
from drifting further on to the sands. In the
distance, the shattered hulk of a wrecked brig is
a warning of what could be their fate if their
efforts should fail. Cooke's searching analysis of
wave forms, and his meticulous treatment of
water, are akin to those of his predecessor,
Clarkson Stanfield, whose work he admired, and
with whom he had worked as a young man.

Samuel Walters 1811–1882

88
The *Red Jacket* outward bound
Oil on canvas, 81·2 × 121·9 cm / 32 × 48 in
Inscribed: S. Walters 1856
Private collection

Samuel Walters built up such a thriving practice in ship portraits that he was able to move out of Liverpool and have a house built for himself and his family at Bootle – a favourite area for the city's more prosperous businessmen. His father Miles Walters was a marine artist, and Samuel began by assisting him with his work. From 1830 onwards he began exhibiting on his own, first at Liverpool and later at the Royal Academy. This characteristic painting portrays the merchant ship *Red Jacket*, with the house flag of the White Star Line flying at her masthead. The *Red Jacket* was built on the eastern seaboard of the United States and her original owners were American. In 1855 she was bought by the White Star Line for £30,000. On one notably fast passage from Liverpool to Melbourne her best average speed for a day's run was 17·4 knots.

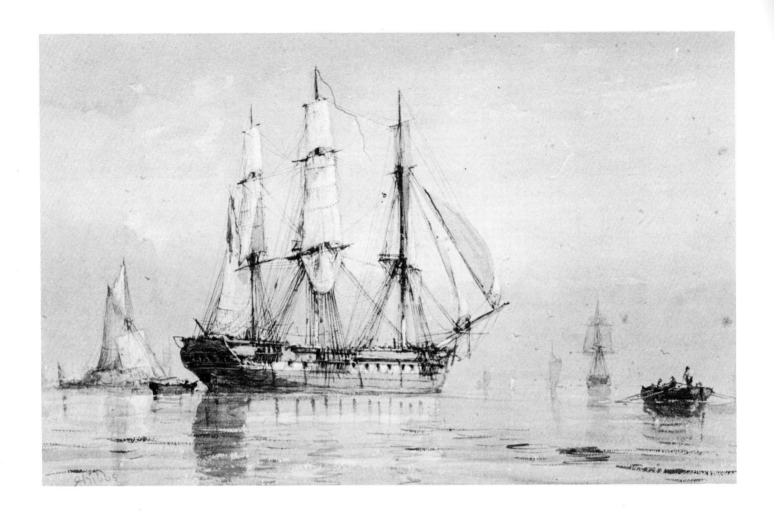

R. H. Nibbs 1816–1893

89
A frigate becalmed
Watercolour, 29·7 × 47·8 cm / 11$\frac{11}{16}$ × 18$\frac{13}{16}$ in
Inscribed: R. H. Nibbs
The Royal Pavilion, Art Gallery and Museums,
Brighton

It is believed that Richard Henry Nibbs was born and brought up in London, but he went to school in Worthing, and from 1847 until his death at the age of seventy-eight, he lived in Brighton. Graves's *Royal Academy Exhibitors* lists his Brighton addresses as 11 Mount Sion Place from 1847 to 1853, 8 Howard Place from 1855 to 1873, and finally 7 Buckingham Place. His father was a musician, and Nibbs himself started his working life as a professional cello player in the orchestra of the Theatre Royal. It seems that as an artist he was self-taught, but he rapidly became accomplished as a watercolourist and an oil painter. In 1836 he published ten views of shipping under the title *Marine Sketches*, and further publications included *The Churches of Sussex* (1851), and *Shipping, Coast Scenes, and Antiquities of Sussex* which was a portfolio of thirty-five plates published in 1876.

He first exhibited at the Royal Academy in 1841 and continued to show one or two works nearly every year until 1888. Most of his exhibited pictures were seascapes or coastal views, but the extensive collection of drawings, sketches and watercolours in the Brighton Art Gallery show that he devoted an equal amount of time to landscapes and architectural subjects. His watercolours are very variable in quality. Sometimes, as in this tranquil scene, he exploits the fluid and transparent qualities of the medium to the full, but too often his watercolours are overworked and have a rather heavy and lifeless air about them.

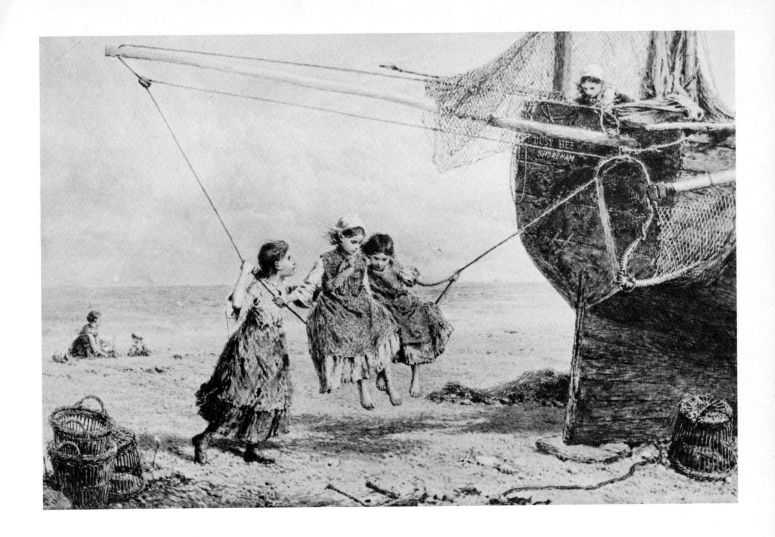

Myles Birket Foster 1825–1899

90
The swing
Watercolour and bodycolour,
28 × 42·9 cm / 11 × 16⅞ in
Inscribed : BF (monogram) 1865
Michael Appleby Esq
(*colour plate* VII)

Myles Birket Foster is one of many Victorian
artists whose work has come back into fashion in
recent years. He was in no way a marine artist
but, like William Collins, he was fond of beach
scenes and frequently used them as a setting for
his charming studies of children. The three
young girls in this picture have ingeniously
fashioned a swing from the outrigger at the stern
of the *Busy Bee*. The metal loop on the end of
the spar at the right is the head-iron of a beam
trawl and is just one of the many details which
have been accurately observed by the artist. The
elderly boat is a Shoreham lugger, and so the
scene is presumably somewhere on the shingle
beach near Shoreham harbour.

91
The sea shore
Watercolour and bodycolour,
19·4 × 27 cm / $7\frac{5}{8}$ × $10\frac{5}{8}$ in
Inscribed: BF (monogram)
Whitworth Art Gallery, Manchester

The freshness and simplicity of Birket Foster's subjects disguises the extremely skilful technique which he employed. He was a most accomplished draughtsman, and his keen observation of natural effects (particularly of clouds, trees and water) and his bold and attractive use of colour help to explain the popularity of his work. Birket Foster was born in North Shields, but came to London at an early age. He was apprenticed to a wood engraver for some years, and much of his early life was devoted to illustrating books and journals. He exhibited at the Royal Academy for the first time in 1859 and thereafter became a regular contributor. In 1863 he built a house at Whitley near Godalming, and although he made several visits to the Continent, he devoted most of his time to painting pictures of the Surrey countryside in which children and milkmaids feature prominently.

John Brett 1830–1902

92
Watergate, Cornwall
Oil on canvas, 20·3 × 38·1 cm / 8 × 15 in
Inscribed: Watergate 24 Aug '81
The Royal Pavilion, Art Gallery and Museums,
Brighton

Every summer John Brett used to set off from Putney with his large family to some remote corner of the British Isles. For three months they would stay in rented accommodation, or the cottage of a friend or acquaintance, and while the children explored the neighbourhood or played on the beach, Brett would fill sketchbooks with carefully annotated drawings. He would also paint a number of small oil sketches such as this one, which he might later use as the basis for a full-size canvas. From June to September 1881 the Brett family stayed at Bothwicks, near Newquay. By this date Brett was making use of photographs as an aid to his work, and he set aside one day a week for this pursuit: 'Today Daddie has been photographing as he usually does on Sundays', is an entry in the family diary for 1882, and there is in existence one of his photographs of a rocky beach at the Lizard (very similar to this view) which can be dated to 1876.

Charles Napier Hemy 1841–1917

93
Among the shingle at Clovelly
Oil on canvas, 43·9 × 72·4 cm / $17\frac{1}{4}$ × $28\frac{1}{2}$ in
Inscribed: CNH (monogram) 1864
Laing Art Gallery, Newcastle-upon-Tyne
(*colour plate* VIII)

This astonishing picture was painted by Hemy
at the age of twenty-three, and was shown at the
Royal Academy in 1865, the first year in which
he exhibited there. In some ways it must be
regarded as his masterpiece because none of his
later works ever equalled the extraordinary
intensity, and the vivid sense of atmosphere
achieved in this portrayal of a beach on the
North Devon coast. In this respect the picture
may be aptly compared with John Brett's *The
Stonebreaker* of 1858. Brett's painting of a young
labourer at work on a pile of meticulously
rendered flints was highly praised by John
Ruskin, and no doubt influenced this picture by
Hemy. *The Stonebreaker* was likewise painted
when the artist was in his twenties and it has
often been suggested that Brett's work never
again approached the same quality. Brett was
closely associated with the Pre-Raphaelite
artists, and was strongly affected by the writings
of Ruskin – particularly his observations on
geological formations and mountain scenery. In
his early years as an artist, Hemy's inspiration
appears to have come from the very same
sources.

94
The smelt-net
Oil on canvas, 91·4 × 121·9 cm / 36 × 48 in
Inscribed: C. Napier Hemy 1886
Private collection

Much more characteristic of Hemy's work than *Among the shingle at Clovelly* is this portrayal of fishermen at work. The scene is Falmouth harbour and the curious net being worked over the side of the rowing boat was for catching smelt, a small fish allied to the salmon family. Hemy took up residence in Falmouth in 1883, and bought himself a forty-foot fishing vessel which he converted into a floating studio and named the *Van de Velde*. From this vantage point (and later from a boat of smarter, more yacht-like appearance called the *Van der Meer*) he painted numerous seascapes and picturesque views of the harbour. This painting was exhibited at the Royal Academy in 1887.

W. L. Wyllie 1851–1931

95
Coming up on the flood
Oil on canvas, 66 × 127 cm / 26 × 50 in
Inscribed: W.L. Wyllie 1880
Private collection

The marine paintings of W.L. Wyllie were
much admired in his lifetime, and after a period
of neglect they have become increasingly
popular in recent years. Seamen and maritime
historians particularly value his work for its
documentary accuracy. Wyllie was the son of an
artist and after training at the Royal Academy
Schools he decided to devote his life to painting
all manner of ships and small craft. His prolific
output of watercolours and oil paintings
included the entire range of shipping from
destroyers and battle cruisers down to fishing
boats and sailing dinghies. Perhaps his greatest
contribution was his record of working life on
the Thames and Medway. With a keen eye and
vigorous brushwork he portrayed that nostalgic
era when sail gave way to steam, and when top-
sail schooners and Thames sailing barges
mingled with steam tugs and dirty British
coasters.

BIBLIOGRAPHY

The Dutch School

Bachrach, A.G.H., *Shock of recognition : the landscape of English Romanticism and the Dutch seventeenth century school*, Arts Council exhibition, London 1971

Bernt, Walter, *The Netherlandish painters of the seventeenth century*, London 1970

Maclaren, Neil, *The Dutch School*, National Gallery catalogue, London 1960

Preston, Admiral Sir Lionel, *Sea and river painters of the Netherlands in the seventeenth century*, London 1937

Robinson, Michael S., *Van de Velde drawings in the National Maritime Museum*, Cambridge 1958

Rosenberg, J., Slive, S., ter Kuile, E.H., *Dutch art and architecture 1600–1800*, London 1966

Stechow, Wolfgang, *Dutch landscape paintings of the seventeenth century*, London 1966

Willis, F.C., *Die niederländische Marinemalerei*, Leipzig 1911

The British School

There are very few monographs devoted to British marine artists. Much of the most interesting material is contained in exhibition catalogues, art magazines and journals, and in the files of art galleries and museums, particularly the National Maritime Museum. The following is a selection of the more readily obtainable works, many of which contain detailed bibliographies for further reading.

Brooke-Hart, Denys, *British 19th century marine painting*, London 1974

Butlin, Martin and Joll, Evelyn, *The Paintings of J.M.W. Turner*, New Haven and London, 1978

Cordingly, David, *Marine painting in England 1700–1900*, London 1974

Cox, Trenchard, *David Cox*, London 1947, 1954

Dubuisson, A. and Hughes, C.E. *Richard Parkes Bonington : his life and work*, London 1924

Gaunt, William, *Marine painting, an historical survey*, London 1975

Graves, Algernon, *Royal Academy Exhibitors 1769–1904*, London 1905

Hardie, Martin, *Watercolour painting in Britain*, London 1967–9

Howgego, J.L. and Munday, John, *Edward William Cooke*, exhibition at the Guildhall Art Gallery, London 1970

Johnson, Nerys, *John Wilson Carmichael*, centenary exhibition, Laing Art Gallery, Newcastle 1968

Joppien, Rudiger, *Philippe Jacques de Loutherbourg*, exhibition at Kenwood House, London 1973

Parris, Leslie and Fleming-Williams, Ian, *Constable : paintings, drawings and watercolours*, exhibition at the Tate Gallery, London 1976

Preston, Harley, *London and the Thames : paintings of three centuries*, exhibition at Somerset House, London 1977

Richardson, F. S. *Clarkson Stanfield, R.A.*, 49th annual volume of the Old Watercolour Society's Club, London 1974

Roe, F. Gordon, *Sea painters of Britain*, Leigh-on-Sea 1947

Sharpe, Kenneth and Kingzett, Richard, *Samuel Scott*, exhibition at the Guildhall Art Gallery, London 1972

Sorensen, Colin, *Charles Brooking*, exhibition at Aldeburgh and Bristol 1966

Warner, Oliver, *An introduction to British marine painting*, London 1948

Wilson, Arnold, *A dictionary of British marine painters*, Leigh-on-Sea 1967

Wood, Christopher, *Dictionary of Victorian Painters*, London 1971